Colonies of American Impressionism

Cos Cob

Old Lyme

Shinnecock

and Laguna Beach

Colonies of American Impressionism

Cos Cob

Old Lyme

Shinnecock

and Laguna Beach

by Deborah Epstein Solon with an Essay by Will South

Laguna Art Museum, Laguna Beach, California

Colonies of American Impressionism: Cos Cob, Old Lyme, Shinnecock, and Laguna Beach was published on the occasion of the exhibition (January 9 – April 11, 1999) of the same name organized by the Laguna Art Museum, Laguna Beach, California. The exhibition and book were supported by grants from the Joan Irvine Smith and Athalie R. Clarke Foundation and the Festival of the Arts Foundation, with additional support from Ranney E. and Priscilla A. Draper, Thomas and Barbara Stiles, Joseph Ambrose and Michael Fedderson, Kelvin L. Davis, Ray Redfern (The Redfern Gallery), DeWitt McCall (DeRu's Fine Arts), Jeffrey and Nancy Gundlach, Daniel L. Hansman and Marcel Vinh, the Burroughs Family, George Stern (George Stern Fine Arts), William A. Karges (William A. Karges Fine Arts), Edward Mills, Robert Williamson, and Dr. Mark Judy.

© 1999
Laguna Art Museum
307 Cliff Drive
Laguna Beach, CA 92651–9990.

Library of Congress Cataloging-in-Publication Data
Solon, Deborah Epstein.
Colonies of American Impressionism:
Cos Cob, Old Lyme, Shinnecock, and Laguna Beach / Deborah Epstein Solon, Will South.
 p. cm.
This book accompanies an exhibition.
Includes bibliographical references.
ISBN: 0–940872–24–2 (pb)
1. Impressionism (Art)—United States—Exhibitions. 2. Painting, American—Exhibitions. 3. Painting, Modern—19th century—United States—Exhibitions. 4. Painting, Modern—20th century—United States—Exhibitions. 5. Artist colonies—United States—Exhibitions.
I. South, Will. II. Laguna Art Museum (Laguna Beach, Calif.) III. Title.
ND210.5.I4S65 1999
709' 73'09041—dc21 98–48666
 CIP

Publication Coordinator and Editor:
Terry Ann R. Neff
t.a. neff associates, inc.
Tucson, Arizona

Separations by:
Professional Graphics, Rockford, Illinois

Printed by:
TWP America, inc.

Designer:
Garland Kirkpatrick
helveticajones.com
Santa Monica, California

Cover:
Donna Schuster (1883–1953)
Lily Pond, Capistrano Mission, c. 1928 (detail)
Oil on canvas
24 x 30 in.
Ranney and Priscilla Draper

Contents

Foreword

As cultural theorists often enjoy pointing out, Southern California,
with its motion picture, television, and aerospace industries, is
the mecca of artificial culture. In this "here-today-gone-tomorrow"
culture, our history traditionally has been trivialized and discarded,
leaving a great deal of the past for us to excavate.

Laguna Beach and the Laguna Beach Art Association
(the present Laguna Art Museum) have stood at the center of another
sort of culture in Southern California for more than eighty years.
From the turn of the century through the 1930s, Laguna Beach was
home to the most significant artists' colony on the Pacific Coast.
The Laguna Art Museum has been not only the focal point of this
art colony but, for the last twenty years, instrumental in uncovering
its history as well. Through exhibitions and catalogues such as
William Wendt 1865–1946 (Laguna Art Museum, 1978), *Early Artists
in Laguna Beach: The Impressionists* (Laguna Art Museum, 1986),
and *California Light 1900–1930* (Laguna Art Museum, 1990), the
Museum has explored, and indeed developed, its rich local art history.
Along with The Oakland Museum of California, it has been at the
forefront of a trend among California museums to focus on regional
history, including the Impressionist movement that was centered
in Laguna Beach. More recently, The Irvine Museum has devoted
considerable efforts to this subject matter as well.

What is missing from the many exhibitions originated on
this subject is one placing California Impressionism and the art
colony in Laguna Beach within the national context. The art colonies
that developed at the turn of the century in Cos Cob and Old Lyme,
Connecticut, or Shinnecock, Long Island, for example, bear many

resemblances, as well as differences, to the growth and popularity of Laguna Beach. This scholarly investigation comparing the efforts of Laguna Beach artists to those working within these three regional art colonies is the final offering in a year-long celebration of the Laguna Art Museum's eightieth anniversary, which has stimulated a renewed interest in what makes Laguna Beach and the Museum unique to the West Coast.

The idea for *Colonies of American Impressionism* came from the Museum's exhibitions committee, an advisory group of curators and art historians who specialize in California art. The group is composed of Deborah Solon, Miriam Smith, Karin Schnell, Michael McManus, Greg Escalante, Jeannie Denholm, Jacqueline Bryant, Janet Blake, Maudette Ball, and Susan M. Anderson. Two of the committee members in particular helped to conceptualize the exhibition and provided critical feedback during its course. Susan M. Anderson, a former chief curator of the Laguna Art Museum, developed the idea for this exhibition several years ago while still at the Museum. Janet Blake, as the curator of *Early Artists in Laguna Beach: The Impressionists*, brought a seasoned perspective to the project.

I am deeply grateful for Deborah Solon's commitment to the exhibition, which would not have materialized without her. As guest curator, she did an exemplary job of organizing the exhibition, writing an essay for the catalogue, and supporting the Museum's efforts to find underwriting for the project.

Catalogue essayist Will South was a pleasure to work with and brought invaluable ideas to the project. Terry Ann R. Neff, the publication coordinator and editor, provided excellent and incisive editorial commentary, gave the project direction, and took the catalogue through production. Garland Kirkpatrick, the catalogue designer, provided a truly elegant and inventive design.

I cannot thank Ray Redfern enough for being the first to believe in the project. It was his initial contribution that helped us to begin planning the exhibition. He also greatly assisted us by helping to find additional funding sources. Crucial support from the Joan Irvine Smith and Athalie R. Clarke Foundation finally made the exhibition viable.

Additional support was generously given by the following: Ranney E. and Priscilla A. Draper, Thomas and Barbara Stiles, Joseph Ambrose and Michael Feddersen, Kelvin L. Davis, the Festival of Arts Foundation, Ray Redfern (The Redfern Gallery), DeWitt McCall

(DeRu's Fine Arts), Jeffrey and Nancy Gundlach, Daniel L. Hansman and Marcel Vinh, the Burroughs family, George Stern (George Stern Fine Arts), William A. Karges (William A. Karges Fine Arts), Edward Mills, Robert A. Williamson, and Dr. Mark Judy.

The staff of the Laguna Art Museum has ably assisted with the many details of fundraising, coordinating, publicizing, and installing the exhibition. For their professionalism and hard work, I warmly thank them all, especially Janet Blake, Jenny Boccardo, Ellen Girardeau, Mitch Goldstein, Andrea Harris, Nancy Hightower, Wendy Sears, and Patricia Wright.

Finally, I extend my deepest gratitude and appreciation to the lenders for their essential participation in this timely project.

Bolton Colburn
Director

Acknowledgments

The realization of this exhibition has taken the combined efforts of
many dedicated people. I would like to thank three special individuals,
Jane Janz, Susan Larkin, and Nancy Moure, who have graciously
shared their research and expertise. The staffs of various institutions
throughout the country have cooperated in gathering materials
and research for this project. I would like to acknowledge especially
the following: D. Scott Atkinson, San Diego Museum of Art; Jack
Becker, Florence Griswold Museum; Karen Blanchfield, Bush-Holley
House Museum; Nancy Hall-Duncan, Bruce Museum; Toni Hulce,
Lyman Allyn Art Museum; Whitney Ganz; Renee Minushkin, Parrish
Art Museum; David O'Hoy; Lisa Peters, Spanierman Gallery; and
Jean Stern, The Irvine Museum.

I extend my gratitude to the staff of the Laguna Art Museum
and especially to the museum's director, Bolton Colburn, who has
stood firmly behind this project. Without his support this exhibition
would never have occurred.

Lastly, I owe a debt of gratitude to my family. My husband,
Neil, and daughter, Alexandra, have both shown tremendous patience
and encouragement throughout this endeavor. To them I dedicate
this catalogue.

Deborah Epstein Solon
Guest Curator

LAGUNA BEACH

OLD LYME

COS COB

SHINNECOCK

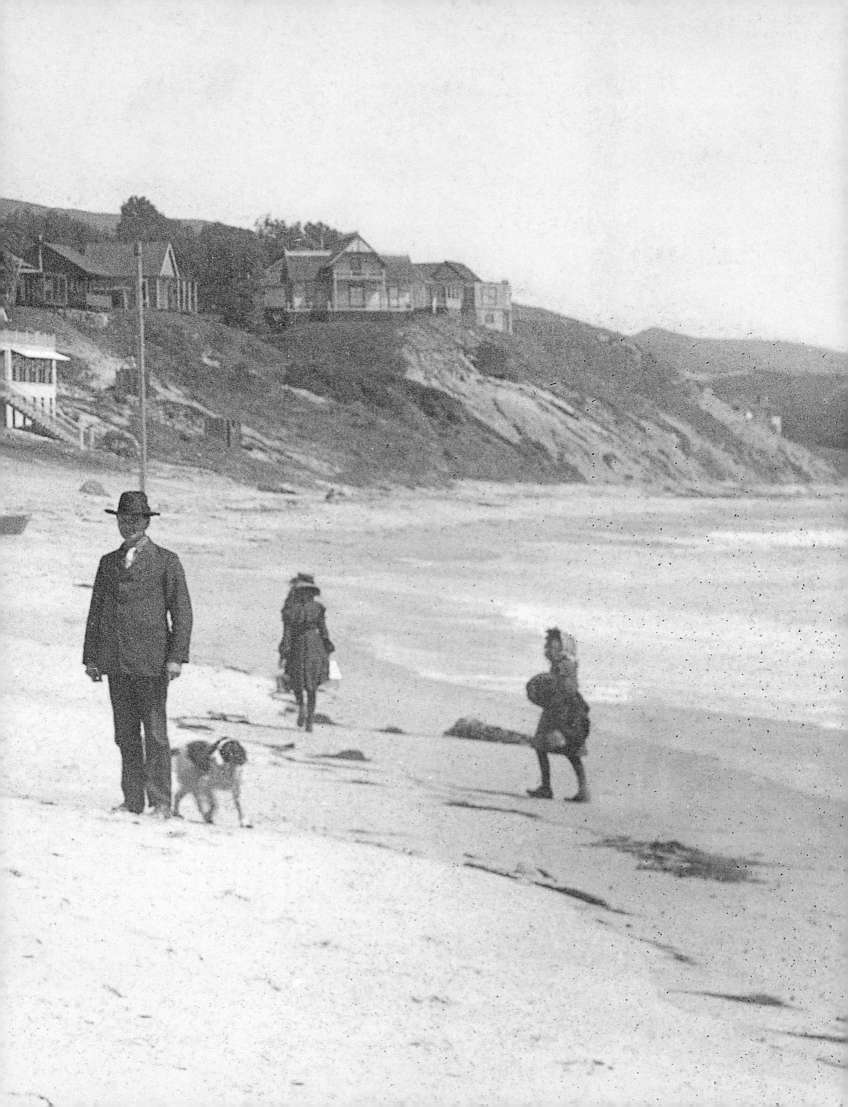

Laguna Beach: The Spirit of an Art Colony
Will South

Laguna Beach is a community of the American West located on the shore of Southern California, about fifty miles below the city of Los Angeles. Old Lyme is in Connecticut on the East Coast of the United States, over two thousand miles and, one hundred years ago, roughly five to six days of overland travel from Laguna. Giverny is in France, then a ten-day sea voyage from America and a two-hour train ride west of Paris. In the nineteenth century, and to a great extent even today, Laguna was separated from Old Lyme by dramatic differences in Western versus Eastern lifestyle as well as distance, while residents of these two tiny American places had little in common with the history, language, and customs of the Givernois. Each of these three villages, for villages they were in the late nineteenth and early twentieth centuries, had its own particular climate, geography, and modest architecture distinct from the others. What binds them together historically is that each one became a destination for artists, a consciously chosen residence, a site of common experience—an art colony.

There were many other art colonies founded during the decades bordering 1900, equally remote and equally unique: Brown County, Indiana; Gloucester, Massachusetts; Taos, New Mexico; and Carmel-by-the-Sea, California, to name a few. All colonies, both here and abroad, offered similar attractions for artists—picturesque landscape, respite from routine, and camaraderie among them. But how they each differed in spirit—in a specific time and place—and how this spirit supported and inspired the work of individual artists are integral parts of the still-unfolding story of American Impressionism.[1]

South end of the main beach, Laguna Beach, California, c. 1913. Photograph courtesy of Jane Janz

1.
George Brandriff (1890–1936)
Diver's Cove, Laguna Beach, c. 1930
Oil on canvas, 24 x 28 inches
Marcel Vinh and Daniel Hansman

18

The general definition of a colony is "a group of people who settle in a distant land but remain under the political jurisdiction of its native land."[2] Laguna, Old Lyme, and Giverny (serving here as disparate yet similar examples) all were distant lands, and their colonists—the painters—remained to a great extent under the aesthetic jurisdiction of the world's art centers: Paris, Munich, London, and New York among them. Yet, as with the original Thirteen Colonies of the United States, one thinks of colonists as dissenters, adventurers, and experimenters—persons willing to abandon, for one reason or another and however temporarily, the established order. Just as the Thirteen Colonies developed and thrived an ocean away from the quotidian existence of England, while owing much of its cultural fabric to England, so the members of artists' colonies thrived far from the madding pressures of salons, galleries, and professional art critics, while owing much of their artistic production to aesthetic paradigms of the period.

But an art colony was not a province, a state, or a protectorate. It was not a club, or a formal organization of any kind. There were no rules to follow, no monetary dues. A general definition of a late nineteenth- or early twentieth-century art colony might read as follows: "a group of artists who settled in a distant land and shared common aesthetic pursuits; whose collective presence was a defining characteristic of their environment as much as that environment was a defining characteristic of their art; and whose decision to colonize was born of ideology, not practicality or necessity."

The second and third parts of the definition are as important as the first. No group of artists could ever be a *defining* characteristic of cities as large, diverse, and complicated as Paris or New York. But the presence of artists at Laguna, Old Lyme, and Giverny was in each instance an integral part of the character of those communities; artists were prominent residents, interacted intimately with their neighbors, helped shape the local economy, and were, as a group, often the feature of that community best known to outsiders. The colony filled the area, and the specific geography and atmosphere of the area filled their art—the relationship was symbiotic in a very real sense. All art colonies of the period had this in common.

The fourth part of the proposed definition serves to clarify the historical reality of an artist's choice to associate with a colony: the earlier art colonists (those of the nineteenth century and before

2.
George Brandriff
Studio, Laguna Beach, c. 1930
Oil on canvas
24 x 28 inches
Private Collection

the First World War) were not coerced, cajoled, or pressured to join, nor were they running from the supposed oppression of the relentlessly industrializing metropolis. Even if urban flight motivated later colonists, one did not need a colony to run away. On the contrary, joining a colony was hardly an act of defiance or loathing: no member of any art colony need reject the city or representatives of the art establishment—museums, galleries, and critics. Most colonists kept in contact with galleries, showed in major exhibitions, and were very likely to be city dwellers and only part-time colony residents. Far from being hermetic iconoclasts, colonists were well aware of contemporary developments in style and taste, and the vast majority of them were committed to the most internationally popular mode of painting then practiced: Impressionism.

Indeed, the rise in popularity of art colonies in the late nineteenth and early twentieth centuries was inseparable from the rise in popularity of outdoor painting. Venues for the exhibition of Impressionist art could readily be found, and the market for it

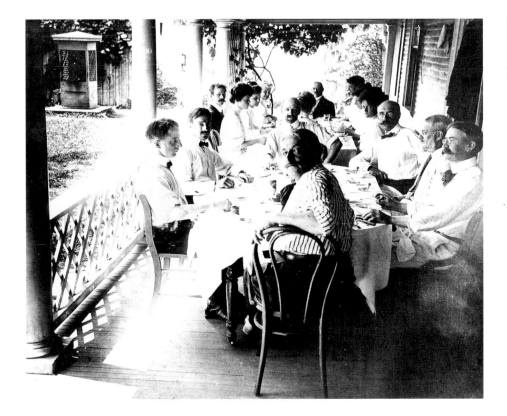

Artists on the back porch, Florence Griswold House, c. 1903. Photograph courtesy of the Florence Griswold Museum, Old Lyme, Connecticut

but, more importantly, offered the desired spiritual ambiance: the art colony was its own art establishment, where, for as long as any painter could afford to stay, nothing was more important than the art being produced then and there, and the rest of the world dropped away. The colony at Laguna Beach shared this essential atmosphere with other plein-air painting centers, and the art produced there may be compared with all the other colonies for its interest in outdoor light and color, and the colony's members for their relatively unconventional lifestyles. But, for all the similarities, the collective spirit of the art colony at Laguna Beach was distinct from that of Old Lyme or Giverny, or even from Taos, another Western colony. Laguna's Impressionist painters were California Impressionists, a sizable group of artists who, for all their individual differences, shared an unshakable sentiment about the land itself—that nature is everywhere bountiful, innervating and good, as well as mystical, mysterious, and romantic. This attitude thoroughly pervaded California art and remained vital long after it had ceased to be a factor in the East, including at such centers as Old Lyme.

The source of this predominant aesthetic regarding nature was inherited by the California Impressionists from earlier American painters and, indeed, from American culture itself. Nineteenth-century Americans believed nature was created by God, and art by mere humans. The role of the artist was to mirror the glory of nature, its order and plan, and to evoke in the viewer the same feelings of awe, intimacy, and miracle that nature evoked. Truth was *in* nature, *in* creation, and therefore landscape became a more important subject than still life or genre painting could ever be, which were, again, the products of mortal thought. It was the landscape that could be morally edifying and uplifting in addition to expressing religious or spiritual conviction. So complete was the collective acquiescence to the preeminence of nature by the California Impressionists that, unlike their peers on the East Coast, they never developed a figurative tradition of any significance. Nor, for that matter, were they as a group prolific or particularly accomplished in genre painting or in still life.

The California Impressionists were able to carry forward the traditional desire found in America's Hudson River School painters—to replicate nature and convey its spiritual dimensions— in large part because California saw itself as the last Eden, a land

3.
Benjamin Chambers Brown (1865–1942)
The Jeweled Shore, c. 1923
Oil on canvas
34 x 36 inches
Private Collection

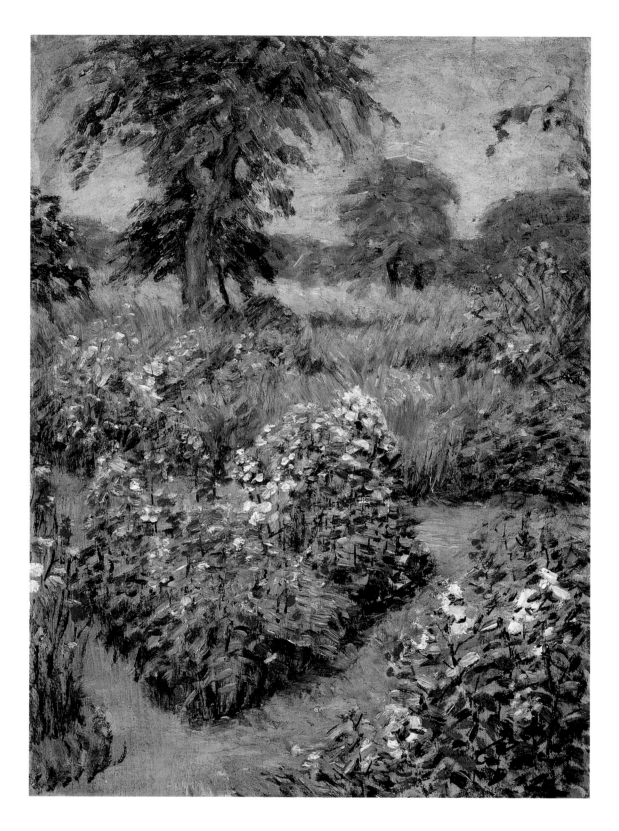

4.
George Brainerd Burr (1876–1939)
Old Lyme Garden, n.d.
Oil on panel
12 x 9 inches
Florence Griswold Museum,
Old Lyme, Connecticut,
Gift of Mrs. Patricia Burr Bott

of infinite resources, opportunity, and healing climate. To be
sure, a similar cultural assumption had been attached to America
in general as the promised land, but had deflated in the post–
Civil War East. At the turn of the century, it was the West that was
still vast and unspoiled, and California specifically that was a
land of gold and dreams. Thus, while some Eastern Impressionists
such as Childe Hassam systematically adapted the stylistic achieve-
ments of the French (Hassam's flag series, for example, which
frankly mimics Monet's), the Californians found it natural to perpetu-
ate the pictorial values of Thomas Cole, Frederic Church, and
Ashur B. Durand and their Western counterparts, Virgil Williams,
Thomas Hill, and Albert Bierstadt—all painters who sought the
grandeur of creation in their work.

 From the original French Impressionists, the California
Impressionists adopted only certain surface effects and none
of the French tendency toward sensuous imagery for its own sake.
What the California painters took from Impressionism served
to intensify the sense of realism, not abstraction, in their paintings.
The color they saw in an Impressionist canvas—vivid blue skies,
bright red poppies, purple shadows—closely resembled color
as actually observed while painting in the field. Such color was a

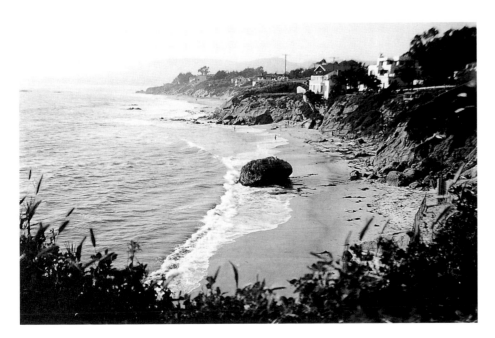

Coastal view, Laguna Beach,
California. Photograph
courtesy of Jane Janz

visual truth that reached beyond the polished and precise, yet predominantly brown and gray, descriptions of things such as branches and rocks found in the work of Williams, Hill, and Bierstadt. Californians saw that the way French Impressionists painted masses of leaves that could not be counted, becoming instead a plane of meshed strokes—more nearly approximated seeing nature out-of-doors and occasionally out of focus, as opposed to the constant atmospheric clarity within the studio. To paint this way was not inconsistent with the facts of nature. And the intimate scale of Impressionist painting was appealing: not all experiences in the landscape were heroic and theatrical—to the contrary, much of nature's poetry could be quiet and reclusive.

This fundamental feeling Californians had for their art was articulated in the 1916 tome *Art in California*, published on the heels of the Panama-Pacific Exposition in San Francisco. Michael Williams, in his essay "The Pageant of California Art," wrote the following:

> *Unless art, like man, believes in and is obedient to the spirit of God, it is doomed to madness, decay, and death....*
> *This is a state [California] of natural health. It is the land of the great out of doors, a region where art may touch the life-giving bosom of Mother Earth once more, and be fructified anew; where it may put aside its dreary, tortuous intellectualism and the blighting madness of self-deification, and turn its eyes once again to the stars, to the great mountains, and to the sea, not merely for their own sakes, but because, real and actual as they are, they are but symbols of divine realities.*[3]

The art of William Wendt is a realization of this attitude. An artist of international credentials, a pivotal leader of the California Art Club, and one of California Impressionism's most eloquent and capable representatives, Wendt always gravitated toward remote places in which to live and work. He purchased property in Laguna as early as 1905, though he did not finish building a studio there until 1918.[4] He had visited California for the first time in 1894 with his friend and colleague Gardner Symons, who had established a studio south of Laguna Beach in 1890, and in 1896–97 the two enjoyed living at and painting the environs of Rancho Topanga Malibu Sequit,

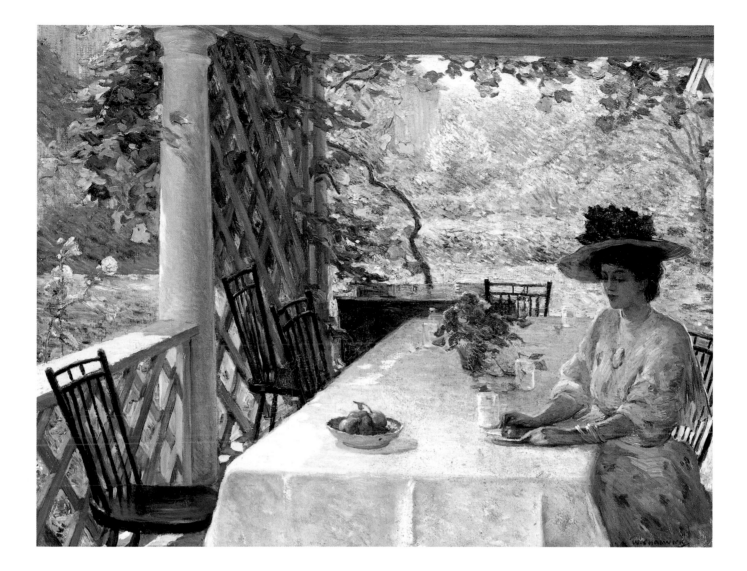

5.
William Chadwick (1879–1962)
On the Porch, c. 1908–1910
Oil on canvas
24 x 30 inches
Florence Griswold Museum,
Old Lyme, Connecticut,
Gift of Elizabeth Chadwick O'Connell

6.
William Merritt Chase (1849–1916)
The Chase Homestead, Shinnecock, c. 1893
Oil on panel
14 1/2 x 16 1/8 inches
San Diego Museum of Art,
Gift of Mrs. Walter Harrison Fisher

the land which is today best known simply as Malibu. While there, Wendt expressed his feelings toward nature in an 1898 letter to his artist/friend William Griffith, who also would eventually find his way to Laguna: "Here, away from conflicting creeds and sects, away from the soul-destroying hurly-burly of life, it feels that the world is beautiful; that man is his brother; that God is good."[5]

However, in the first decades of the twentieth century, the "soul-destroying hurly-burly of life" was to be found not just in the city with its skyscrapers, traffic, and machines—things Wendt would have considered "hurly-burly"—but in philosophies and/or attitudes that thrived on conflict, controversy, and revolution, such as those held by modern artists. Wendt was an ardent foe of modern art, saying once that: "If they [modern artists] could only be induced to look at them these flip young painters would learn a lot from the American landscape painters of a past generation—even from the much despised Hudson River School [who] studied nature with a reverent thoroughness that should put many of our present day painters to the blush."[6]

Places like Laguna were not for Modernists who, Wendt no doubt felt personally, were not really artists at all. The role of the painter was to sustain a belief in art as a vehicle of emotional and intellectual uplift, of art as a door that opened the mind and heart to both the natural glories and the spiritual mysteries incarnated by nature. As a painter, Wendt practiced this "reverent thoroughness," as evidenced by his *Sermons in Stone* (cat. no. 66). Here, nature

Left: William Wendt, 1929.
Photograph by George Hurrell,
Laguna Art Museum Archives

Right: William Griffith painting
on Laguna Beach, California, c. 1925.
Photograph Laguna Art Museum Archives

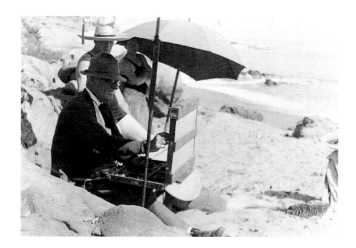

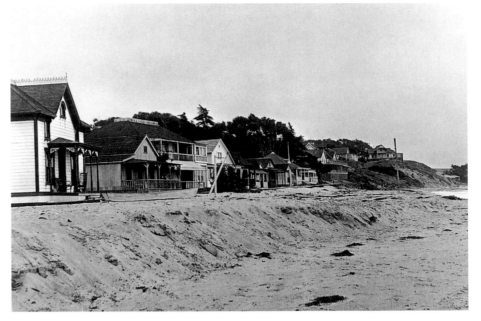

Houses on the main beach,
Laguna Beach, California,
c. 1910. Photograph courtesy
of Jane Janz

is effulgent, dramatic, and harmonious, described with Wendt's
trademark use of sweeping, interlocking shapes while the title implies
a mythic region of peace.

Wendt was not alone in his search for the transcendent through
landscape. Late in 1914 Guy Rose returned to his native California
after having achieved impressive successes both in New York
and abroad. Once settled in Alhambra (a suburb of Los Angeles),
he wasted no time in venturing down to Laguna in 1915 and was
exhibiting work completed there early in 1916.[7] One of these
is *Laguna Rocks, Low Tide* (cat. no. 49), a typical work for Rose that
explores his Impressionist-derived interests in outdoor light and color.
It is also a work of consummate balance: the warm ochre, orange,
red, and sienna of the foreground rocks contrast evenly with the cool,
blue ocean while the solidity of the sunlit cliff is both enhanced
and defined by the empty, vaporous sky behind it. The visible world
is always more than a source of subject matter, it is a testament
to pervasive, controlling order. As with Wendt, the elements of the
landscape for Rose are stand-ins (they cannot be otherwise) for
his own idealizing perceptions of nature.

Rose was the classic inveterate colonist: when he lived in
New York City in the 1890s, he sought out Woodstock; when in Paris

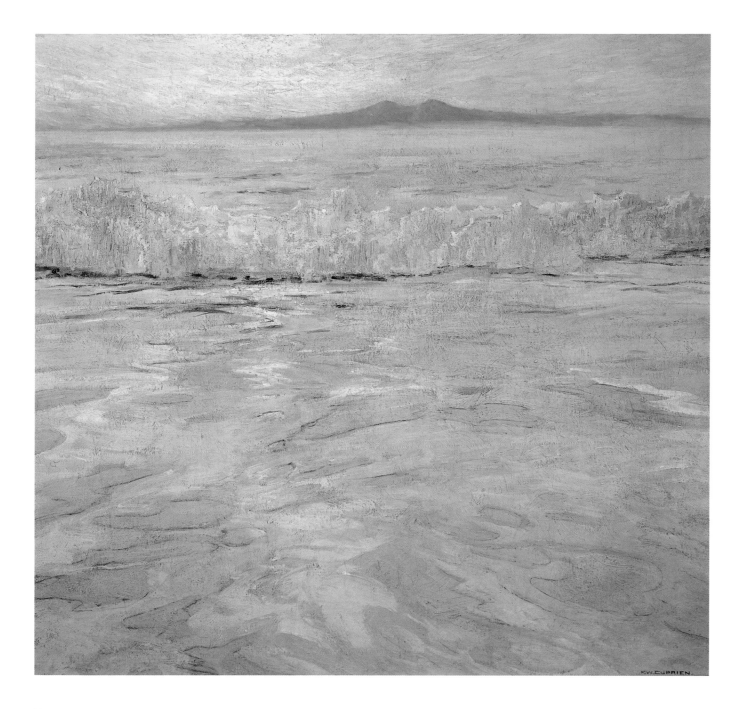

7.
Frank W. Cuprien (1871–1948)
Poème du Soir, 1925
Oil on canvas
32 x 35 inches
Laguna Art Museum/Orange County
Museum of Art Collection Trust, California,
Gift of the Estate of Frank W. Cuprien

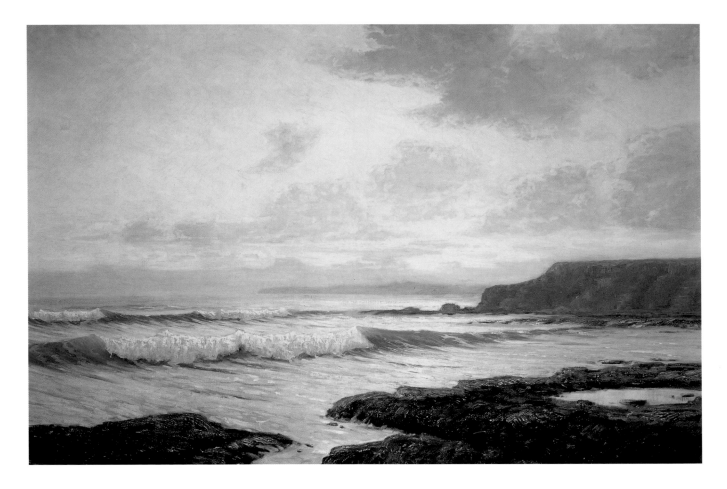

8.
Frank W. Cuprien
Evening's Iridescence, c. 1925–30
Oil on canvas
32 x 48 inches
Joan Irvine Smith Fine Arts, Inc.,
Laguna Beach, California

Edgar Payne, 1926.
Photograph by George Hurrell,
Laguna Art Museum Archives

as a student, he sought out Giverny, then lived there from 1904 to 1912;
back on the East Coast from 1912 to 1914, he painted at Old Lyme
and taught a summer course at Narragansett, Rhode Island. Though his
career as an artist routinely called for interaction with urban centers,
he drew sustenance and inspiration from the faraway places in his world.

Again, he could have found marvelous landscapes in proximity to turn-of-the-century New York or Paris, but he chose distance. A shy, quiet, unpretentious person, Rose was most at home where there were the fewest distractions from his art, or from the solitary pursuits of hunting and fishing. Living in a colony gave his life— and thus his art—an unchallenged focus, clarity, and simplicity.

Maurice Braun is yet another artist associated with the Laguna Beach art colony who fully shared Rose's and Wendt's vision of nature as sanctuary, a view fundamental to the concerns of all the early California Impressionists.[8] Braun's paintings are images of plenitude and harmony undisturbed by development; his emphasis is on the balance between nature and spirit. Part of Braun's aesthetic temperament was drawn from his own Theosophical beliefs, though these beliefs were wholly consistent with the dominant ideology promulgated by the first generation of California Impressionists. His desires and his artistic goals were aided by the existence of a colony that could provide consensus and confirmation.

Braun's *Land of Sunshine* (The Fieldstone Collection, not in exhibition) seeks, as does Wendt's *Sermons in Stone*, the nurturing yet epic image, the calm yet spectacular vista. Both, like Rose's *Laguna Rocks*, rely on nature's most saturated color and symphonic shapes to convey the widely shared belief in nature as benevolent gift—and in California as her primary representative. To be sure, the California Impressionists could paint small, intimate, and unpretentious slices of landscape—and often did—but only inasmuch as such images supported the much grander scheme of representing Creation in its most perfect moments. By contrast, East Coast Impressionists—lacking in the grandiose myth California enjoyed because of its newness, relative remoteness, and near-zealous cultural contentment—had all but abandoned the "grand view" landscape.

Artists Anna Althea Hills and Edgar Payne, who had moved to Laguna Beach in 1913 and 1917 respectively, were the cofounders in 1918 of the Laguna Beach Art Association, the organization that grew out of the vitality of the colony which existed by then. In their work, as in that of Rose, Wendt, and Braun, an awareness of the "real and actual" as "symbols of divine realities" was likewise a guiding sensibility. It was Payne especially who looked to the mountains, over and over again, from the Swiss Alps to California's High Sierra, painting them in monumental scale as emblems of sublime majesty.

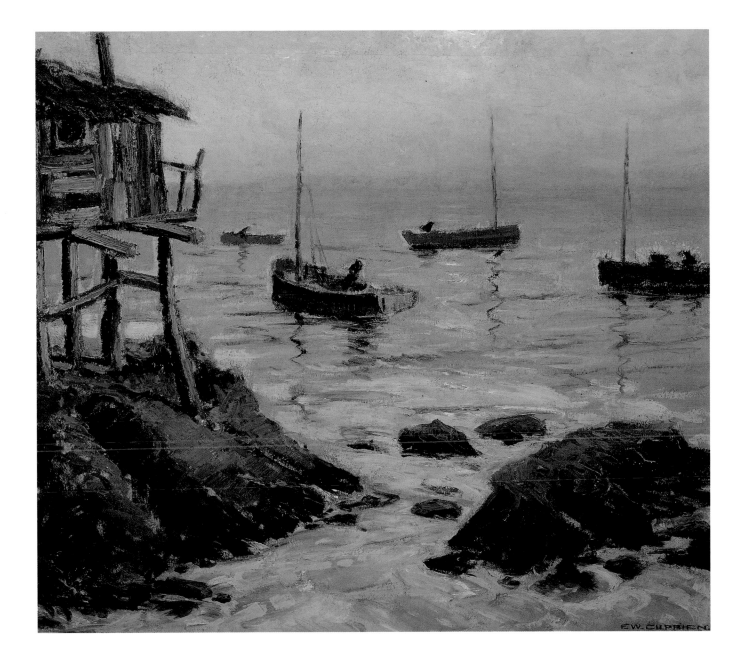

9.
Frank W. Cuprien
The Old Bait House, c. 1925–30
Oil on canvas
24 x 28 inches
Private Collection

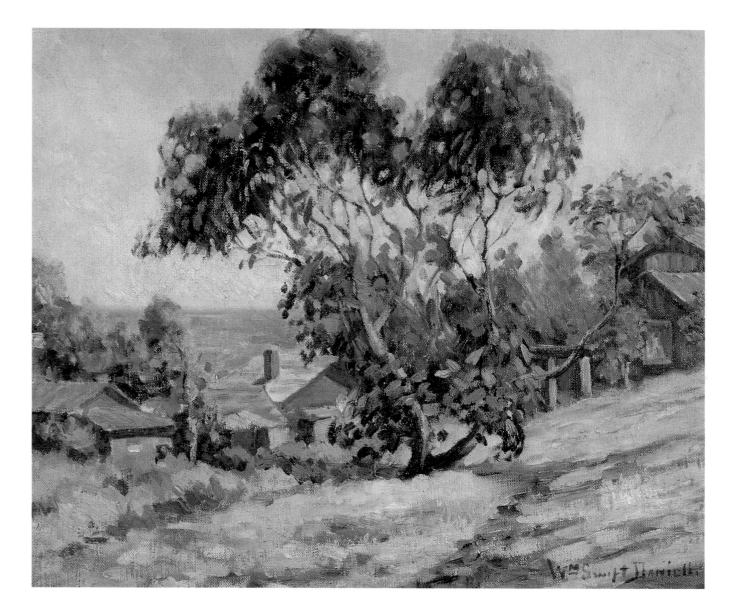

10.
William Swift Daniell (1865–1933)
My Studio, Laguna Beach, c. 1920
Oil on canvas
16 x 20 inches
Laguna Art Museum/Orange County
Museum of Art Collection Trust, California

Indeed, it is difficult to think of Payne sometimes as painting impressionistically, so much tactile information does he offer. When he turned his attention to Laguna scenes, it was with the same crystalline and geometric gaze (see *Old Laguna*, cat. no. 43). Again, however, this tendency to meld tangible structure (inherited from traditional American landscape painting) with sun-flooded color (derived from French Impressionism) is a defining characteristic of California Impressionism.

In Anna Hills, the spirit of the real and actual is there, too, in works such as her serene coastal view, *High Tide, Laguna Beach* (cat. no. 22), which revisits the theme of the isolated place of quiet and contemplation.

Coastal views were, of course, a staple of the Laguna Beach art colony's production. Frank Cuprien had moved to Laguna in 1914, and with Hills and Payne, was an original member of the Art Association. Cuprien specialized in soft, gauzy interpretations of the Pacific, one of these being *Poème du Soir* (cat. no. 7). In the hesitant fragility of this image, Cuprien captured what so many California Impressionists sought in their work: the dreamlike reverie that could be induced by the ocean, and a hint of its impenetrable infinitude and mystery.

In 1918, the year of the Laguna Beach Art Association's founding, one source claims that there were between thirty and forty artists living in Laguna Beach.[9] This number may seem high, and, in fact, current research shows that there were considerably fewer. One artist living part-time in Laguna was Donna Schuster. Schuster had studied with William Merritt Chase in the summer of 1914 in Carmel, and in the fall of that year she painted a series of watercolor sketches in San Francisco depicting the construction of the Panama-Pacific International Exposition. In 1923 she built a studio/home in Griffith Park, Los Angeles. The ease with which Schuster and others moved about, resulting in an indeterminate number of artist/residents at Laguna, tells us something else about the spirit of the Laguna colony: the colonists were indistinguishable from the rest of the Laguna residents. This was not true of colonies such as Giverny or Taos.

Painters were attracted to Taos and Giverny because life in a colony accorded with their ideology, that is, with their belief in what a painter's life should be and could achieve. But in Giverny, no

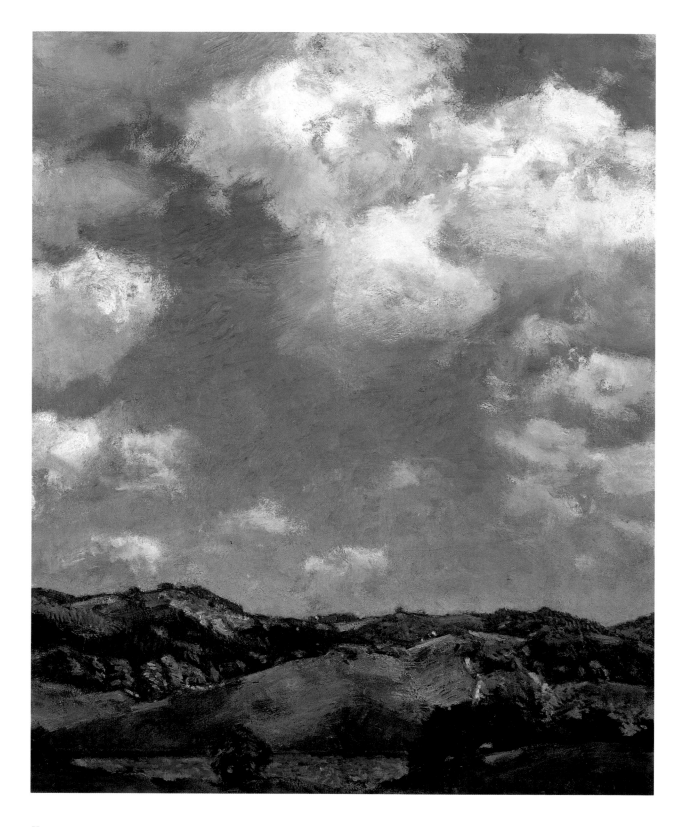

11.
Charles Davis (1856–1933)
Sky, c. 1922
Oil on canvas
36 x 30 inches
Lyman Allyn Art Museum,
New London, Connecticut

outsider could ever really become a French villager, let alone adopt the local way of thinking. No transplanted New Yorker in Taos had a chance of becoming a Native American, with such completely different customs and beliefs.

In Laguna, the townspeople and the painters were all Californians in a village with a very short, very recent history. There was a unity of culture, place, and identity not found in colonies like Taos or Giverny, where painters were not ever really "home," but rather expatriates. In Laguna, painters could share in the strong, nationalistic sentiments that Californians had about their state. Those sentiments were expressed by Alma May Cook, a Los Angeles critic in charge of the educational activities of the California Art Club, in her essay "What Art Means to California":

> *We [Californians] are in a way isolated, we are far distant from the older centers of art, but that will prove a blessing for which we should thank a kind, but unappreciated fate. Because of our distance we are more self-dependent, and therefore more self-reliant. We but hear of the latest "style" in art. The newest "ists" and "isms" are but names to us. We are not even exposed to the contagion. But let a great truth come, even in the most remote part of the earth, and its very truth gives it vitality to cross ocean and continent, so that only that which is really worthwhile finds its way to our golden shores to remain and become a part of the growing art. Yet another reason for thankfulness: we lack the "atmosphere" which attracts the dilettante. We are as yet something of pioneers and it is only the true artist in heart and soul who is willing to help build up the art to come. It is the worthwhile men and women who come to our shores to call them home.*[10]

Artists of the Laguna colony fit Cook's description. They were not dilettantes; the vast majority were professionally trained, widely exhibited, award-winning painters. And the majority believed Cook's assessment that "only that which is really worthwhile finds its way to our golden shores to remain and become a part of the growing art," and what was worthwhile was traditional: solid landscapes bathed in brilliant light and color, where all was right

with the world. They were, without doubt, unlearned in (though not completely unaware of) the latest "ists" and "isms." There was never any sense of urgency—either professionally in terms of self-advertising or theoretically in terms of self-analysis—in or about the colony, as they had not created any reason for it. If there was any single, identifiable reactionary strain among the painters at the Laguna Beach art colony, it was the one shared by all of the California Impressionists against what Alma Cook called "the contagion"— Modern art.

Modern art societies often formed with a political agenda in mind, which was certainly true of the early Modern art societies in Los Angeles that wanted to establish legitimacy, create dialogue, and, ultimately, alter the existing cultural fabric of California. The California Impressionists, including those in Laguna, opposed Modernism and feared its encroachment, and when they could they even prevented it from being exhibited (this occurring in the 1930s, when Modernism had made inroads that far south of Los Angeles). In this sense they had a political agenda, too, but specific political goals were, for the most part, outside their purview. Any art group that united to promote an ideology had to articulate that ideology; artists of the early Laguna colony *lived* their ideology. Their main purpose was to indulge art and nature in equal measure, leaving what Michael Williams called "tortuous intellectualism" to others.

Popular mythology tells us the East Coast possesses the tradition of rigorous intellectualism, while the West has been more successful at the creation of affect and image—Hollywood and Disneyland being the quintessential exemplars. Certainly, the California Impressionists did not write treatises and essays in any quantity or of any distinction, but this is because they accepted so completely what had been written before them by the likes of British critic John Ruskin or American poet Henry David Thoreau. Unlike the French Impressionists who initiated the deluge of Modern art by dematerializing form and by taking modern life for subject matter, the California Impressionists clarified forms and took nature alone for subject matter.

There were, of course, notable exceptions to the pervasive production of landscapes. Critic Everett Maxwell wrote in his review of the 1913 exhibition of the California Art Club that

12.
Frank Vincent DuMond (1865–1951)
Grassy Hill, 1933
Oil on canvas
24 1/4 x 30 1/2 inches
Florence Griswold Museum,
Old Lyme, Connecticut,
Gift of Mrs. Walter Perry

Jean Mannheim's figure studies were "a welcome variation from the surfeit of landscape renderings that always characterize a Western salon,"[11] and they continued to be throughout that artist's career. Clarence Hinkle, a member of the Laguna Beach Art Association, regularly plied still life and even showed some Modernist inclinations. Joseph Kleitsch, who moved to Laguna in 1920, painted charming glimpses of the town itself (see cat. nos. 31–33, 35, 36), as well as impressive still life and figurative compositions. Among the very few indoor scenes painted at Laguna is Karl Yens's *Studio Interior* (cat. no. 68). In the field of genre painting (scenes of everyday life, the least essayed subject in California Impressionist painting), Arthur Rider, taking his cue from the Spanish master Joaquin Sorolla, painted scenes of people on the beach, as did the pastellist William Griffith, who moved to Laguna in 1920 and became an active member of the Art Association. All such works added together, however—figure, still life, and genre—were dwarfed in quantity by landscapes.[12]

And those landscapes were always in praise of nature, always celebrating the sensuous richness that abounded. They always echoed, however faintly or even unwittingly, the belief in nature as creation and in the artist's need in painting to, as John Ruskin put it, "trace the fingerprint of God." A greater diversity in style and subject matter existed in the East Coast colonies, Taos, and Giverny than ever did at Laguna, evidence of a cosmopolitanism in those colonies that never permeated the heavily insulated ideology of subservience to nature adopted by the Californians. Nudes were a standard subject at Giverny; complex interiors common on the East Coast; genre painting at Taos; landscape was common at all three. The California Impressionists, by comparison, were fixated on landscape, the primary symbol of and path to transcendence.

Laguna's growth as an art colony during the 1910s and 1920s coincided with the cresting in popularity of Impressionism all over California; its demise likewise was but a chapter in the gradual statewide decline of its dominance. The common push toward economic growth and material gain that mushroomed in the 1920s in Southern California, the irrepressible challenge of alternative ways of painting, and the inevitable repetition, tedium, and commercialism that infiltrated California Impressionism's own ranks, all conspired to compromise the school's once clear and untainted aesthetic priorities.[13]

13.
Charles Ebert (1873–1959)
Water's Edge, n.d.
Oil on canvas
19 7/8 x 27 inches
Florence Griswold Museum,
Old Lyme, Connecticut,
Gift of Miss Elisabeth Ebert

The legacy of the Laguna Beach art colony in its paintings and in its spirit—like that of California Impressionism—is an instructive and stimulating one. The Californians extended and perpetuated early American values regarding truth, beauty, and goodness as expressed through traditional landscape, while they assimilated the color and light of Impressionism. Their combination of culture and creativity, their genuine spiritual attachment to nature—to light, color, earth, and atmosphere—and their relentless optimism that advocated pleasure, health, and joy above "tortuous intellectualism," compel our attention still today. We admire their commitment, focus, clarity, and optimism—virtues now enjoying a renaissance in an age of ever-increasing technological complexity and environmental peril as well as spiritual debilitation. The art of the Laguna painters is both a manifestation of those simple, but unspeakably special, virtues, and a bridge to them.

1. For a wide-ranging introduction to the subject of American Impressionism, see William H. Gerdts, *American Impressionism* (New York: Abbeville Press, 1984), and, for a focus on California, his chapter on "Southern California," in vol. 3 of *Art Across America: Two Centuries of Regional Painting, 1710–1920* (New York: Abbeville Press, 1990).

2. *Webster's New World Dictionary*, Third College Edition (New York: Prentice Hall, 1994), p. 276.

3. Michael Williams, "The Pageant of California Art," in Antony Anderson et al., *Art in California: A Survey of American Art with Special Reference to California Painting, Sculpture and Architecture Past and Present Particularly As Those Arts Were Represented at the Panama-Pacific International Exposition* (San Francisco: R. L. Bernier, Publisher, 1916), p. 60.

4. Wendt recalled the following in an interview: "...I first came to Laguna in 1905 at the suggestion of my friend George Simon [sic] who was already established at Arch Beach. At his advice I purchased two lots on which later my present studio was built." From the *South Coast News* (Laguna Beach), June 23, 1944, p. 1. On the studio being finished in 1918, see *South Coast News*, September 31, 1946. Both sources cited in Constance W. Glenn, *In Praise of Nature: The Landscapes of William Wendt* (Long Beach, California: University Art Museum, 1989), p. 16. On Wendt's moving into his Laguna Beach studio, see John Alan Walker, "The Wendts Chronology," in *Documents on the Life and Art of William Wendt, 1865–1946: California's Painter Laureate of the Paysage moralise* (Big Pine, California: John Alan Walker, Bookseller, 1992), p. 52, wherein Walker notes Wendt as being in Laguna in 1918, and cites a March 1919 Wendt letter: "I [Wendt] am living in my new studio and am working after a five months enforced vacation...."

5. Quoted in William A. Griffith, "Foreword," in Los Angeles County Museum, of Art, *William Wendt Retrospective Exhibition* (Los Angeles, 1939).

6. *Los Angeles Times*, June 11, 1922.

7. On Guy Rose, see Will South, *Guy Rose: An American Impressionist* (Oakland, California: The Oakland Museum, 1995). In February 1916, Rose exhibited *Laguna Rocks* and *Near Arch Beach* at the Los Angeles Museum of History, Science and Art.

8. It is useful to distinguish the earliest California Impressionists, those who came to artistic maturity in the 1880s and 1890s, from subsequent generations who were less affected by this world view. This distinction and its ramifications are discussed in detail in Will South, *California Impressionism*, introduction by William H. Gerdts (New York: Abbeville Press, 1998).

9. Merle and Mabel Ramsey, *Pioneer Days of Laguna Beach* (Laguna Beach, California: Hastie Printers, 1967), p. 172. For a more accurate account of artists living in Laguna, see Deborah Solon's essay in this present publication.

10. Alma May Cook, "What Art Means to California," in Anderson (note 3), p. 74.

11. Everett C. Maxwell, "Exhibition of California Art Club," *Fine Arts Journal* 28 (January–June 1913), p. 192.

12. A California Impressionist who excelled in both genre painting and still life was Armin Hansen, who worked in Monterey, California, specializing in scenes of fishermen at work.

13. The story of California Impressionism's rise and fall as the state's dominant artistic style is discussed fully in South (note 8).

What Made Laguna Beach Special

Deborah Epstein Solon

France has the imperishable glory of her Barbizon;
the Eastern United States has its Gloucester;
and the Southwest has its Laguna Beach.[1]

By the end of the nineteenth century, artists had discovered Laguna Beach. Laguna's unique location, nestled between the San Joaquin Hills and the Pacific Ocean, made it one of the most exquisite spots in Southern California. Its climatic extremes, relative inaccessibility, and undeveloped beauty and charm fostered and nurtured an adventurous, colonial artistic spirit. Despite the inherent difficulties of living in Laguna, the sparse population was nothing if not independent, pragmatic, and a bit cocky: they had discovered the "pearl of the Pacific,"[2] a small slice of unspoiled heaven on earth.

 The novel idea of forming an art colony had its roots in nineteenth-century France, in Barbizon, where artists began in the 1820s to congregate outside of Paris to paint outdoors in a natural setting. By the end of the century, several French colonies, such as Giverny and Grez-sur-Loing, were well established and attracted numbers of European and American artists.[3] The appeal of such colonies was largely twofold: they provided a lifestyle alternative to urban living, which in America was coming under deep scrutiny at the turn of the century; and they were located right in the heart of the Impressionist pictorial motifs in favor at the time. Artists could gather to paint out-of-doors, living together in a relatively relaxed community while being free to roam the countryside in search of their inspiration.

 Art colonies sprang up in the United States on both coasts, but primarily in the East, where the artistic tradition, like the settlement of the land, had a longer history. Common to colonies discussed in this essay was the dominance of Impressionism. The very term "Impressionism" is ubiquitous in the language and dialogue of art history. For the purposes of this study, most of the artists discussed fall under the general rubric

Main beach pier, Laguna Beach, California, c. 1930. Photograph courtesy of Jane Janz

14.
Charles Ebert
Lieutenant River, Old Lyme, Connecticut, c. 1920
Oil on canvas
30 x 41 1/2 inches
Spanierman Gallery, LLC, New York

of Impressionist painters. Members of these colonies practiced modified forms of Impressionism, varying in great degree from artist to artist. Nevertheless, the practice of Impressionism, in its variously adapted forms, was the bond that held these colonists and colonies together.

Impressionism was born in France and one of its leading exponents was Claude Monet. Monet's move to Giverny in 1883 helped to solidify the art colony there and established a model for its counterparts in the United States in the years to come. American and other painters congregated at Giverny in order to be in the presence of the Master, in spite of Monet's attempts to guard his privacy and not fraternize with other artists. The residence of a great artist may be one reason for the development of an art colony, but not the only one. Art historian Karal Ann Marling has posited a division of art colonies into the following categories: those that evolved naturally from groups of visiting artists who were drawn to an area primarily for the scenery, and those intentionally planned in hopes of creating a specific political or social environment that would foster the creative arts.[4]

This essay explores Laguna Beach and three East Coast art colonies: Cos Cob and Old Lyme in Connecticut and Shinnecock on Long Island. The first three colonies mushroomed through their discovery by artists who fell in love with the countryside and location; Shinnecock grew with the presence of the American Master William Merritt Chase, but the unique terrain also offered artists an array of visual stimuli.

Old Lyme, Connecticut

Old Lyme is situated in southeastern Connecticut at the confluence of the Connecticut River and the Long Island Sound. As in American art colonies on both coasts, the railroad was one of the keys to its establishment. When Henry Ward Ranger (1858–1916), one of the founders of the colony at Old Lyme, encouraged his agent William MacBeth to visit the beautiful countryside he had discovered, he told him that his "station is Lyme."[5] Under Ranger's direction the colony became a Tonalist enclave, but by 1903 it had begun its conversion into an Impressionist paradise. This transformation was largely due to the arrival of Childe Hassam.

Hassam worked in Cos Cob during 1902, but was in residence in Old Lyme by July 1903, and continued to spend part of his summer there through 1912. With Hassam's arrival the colony once known

as the "American Barbizon" or "Fontainebleau in Connecticut"[6] was transformed into an exponent of the Impressionist aesthetic. Hassam's works from this period, such as *Stone Bridge, Old Lyme, Connecticut* (cat. no. 20), reflect the artist's style of Impressionism: broken brushwork, scumbled surfaces, and dramatic viewpoints.

Old Lyme had an important, if short-lived, summer school, which "from 1902 through 1905... attracted scores of students from all over the country, giving a boost to the local economy, as rooms and barns to let were suddenly in great demand. At the same time, Lyme was being transformed into a place of both seasonal and year-round residences for artists."[7] The school, under the direction of Frank Vincent DuMond (see cat. no. 12), was sponsored by the New York Art Students' League, where DuMond was an instructor for more than fifty years. Unpopular with the local residents of Old Lyme, the school relocated to Woodstock, New York, under the directorship of Birge Harrison.

Although the invasion of students ceased, artists continued to come to Old Lyme. One of the village's chief attractions was the gathering place for artists known as the Florence Griswold House.[8]

Childe Hassam outside his studio behind the Florence Griswold House, Old Lyme, Connecticut, c. 1903. Photograph courtesy of the Florence Griswold Museum, Old Lyme, Connecticut

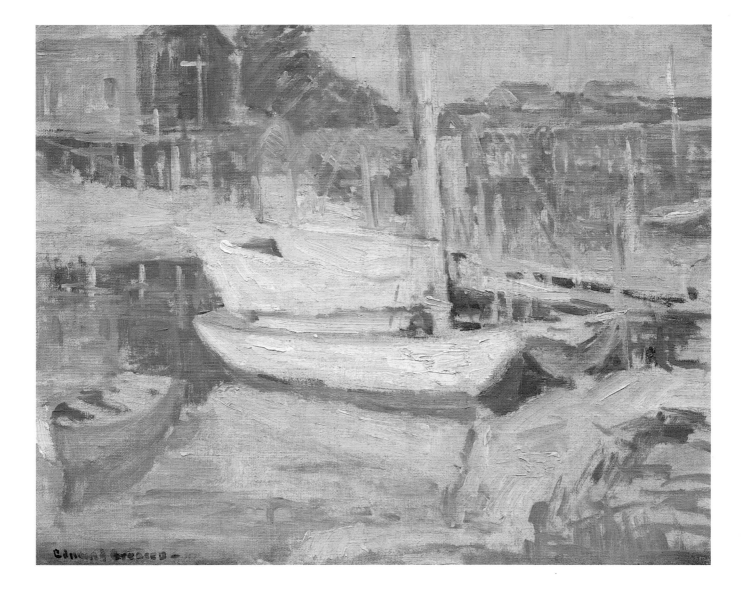

15.
Edmund W. Greacen (1876–1949)
Shipyard, Old Lyme, Connecticut, c. 1910
Oil on canvas
16 x 20 inches
Spanierman Gallery, LLC, New York

54

16.
Edmund W. Greacen
The Old Garden, c. 1912
Oil on canvas
30 1/2 x 30 1/2 inches
Florence Griswold Museum,
Old Lyme, Connecticut,
Gift of Mrs. Edmund Greacen, Jr.

Florence Griswold's family established the boarding house, and she assumed its responsibilities following the death of her mother. Miss Florence herself was one of the central attractions: her magnanimous nature and infectious personality helped establish an environment comfortable for artists. One of the most famous images of the Griswold House with its proprietress is Willard Metcalf's *May Night* (cat. no. 40). Metcalf was in Old Lyme periodically during 1905–1907, a juncture pivotal for his Impressionist style. Undoubtedly his most recognized work from that period, the painting shows the templelike, illuminated boarding house with its ethereal hostess almost hovering outside the entrance. Although Metcalf offered the painting to his landlady in lieu of rent, she refused, recognizing it as one of Metcalf's best. It went on to win the Corcoran Gold Medal the following year.[9]

Nearly all the rooms in the Griswold mansion were converted into guest bedrooms; the barns and buildings were transformed into working studios. The gardens, grounds, and nearby Lieutenant River furnished artists with rich source material for their work. William Chadwick first came to Lyme in 1903 and settled there permanently

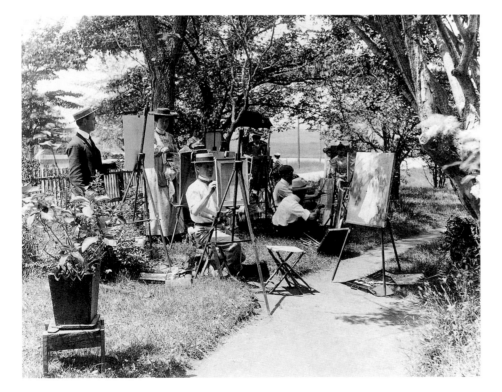

Summer art classes in Old Lyme, Connecticut, c. 1910. Photograph courtesy of the Florence Griswold Museum, Old Lyme, Connecticut

in 1915. His *On the Porch* (cat. no. 5) features the side porch of the Griswold home and a solitary female figure, rendered with an Impressionistic palette and loose brushwork. Guy Wiggins, son of the artist Carleton Wiggins, also settled in Old Lyme. His *Church on the Hill* (cat. no. 67) depicting Grassy Hill where DuMond and other artists lived, employs plunging perspective, loose brushwork, and a light-infused palette.

Hassam's presence drew other artists interested both in Impressionism and in being in proximity to him. Walter Griffin, Gifford Beal, and Edward Rook came to the community. Although she always remained partial to Hassam, Florence Griswold allowed the resident artists to establish a hierarchy of who could board at the house. This was a cliquish group; students and casual tourists were not welcome.[10]

Cos Cob, Connecticut

"The first train chuffed across the newly completed Mianus River Bridge on December 27, 1848. By 1870, when the Cos Cob railroad station was built, it took about eighty minutes to get to midtown Manhattan. A special train, added in 1892, made the run in just thirty-eight minutes."[11] Cos Cob is one of several sections of Greenwich, Connecticut, located approximately thirty miles from New York City. The railroad served as a vital link between the two. The railway and railroad bridge became common subjects for artists in Cos Cob. Elmer MacRae's *Railroad Bridge, Winter* (cat. no. 37) underscores the nostalgia for a less complicated life that artists were already feeling during the machine age. The juxtaposition of the railroad in the background spewing its white puffs of smoke, to the horse-drawn buggy in the foreground, chronicles the rapid changes indelibly altering the landscape.[12]

The foundations for the art colony at Cos Cob were laid by the artists John Twachtman and J. Alden Weir. In 1889, the same year he was appointed to the faculty of the Art Students' League in New York, Twachtman settled permanently in Greenwich.[13] Weir had acquired property in Branchville, Connecticut, twenty miles from Greenwich, in 1882. By 1892 Twachtman was offering plein-air painting instruction in Cos Cob, generally for a period of three months. In 1892 and 1893 he and Weir taught together, attracting a wide spectrum of students ranging from amateur to professional painters. According

17.
William Griffith (1866–1940)
In Laguna Canyon, 1928
Oil on canvas
30 x 40 inches
The Irvine Museum,
Irvine, California

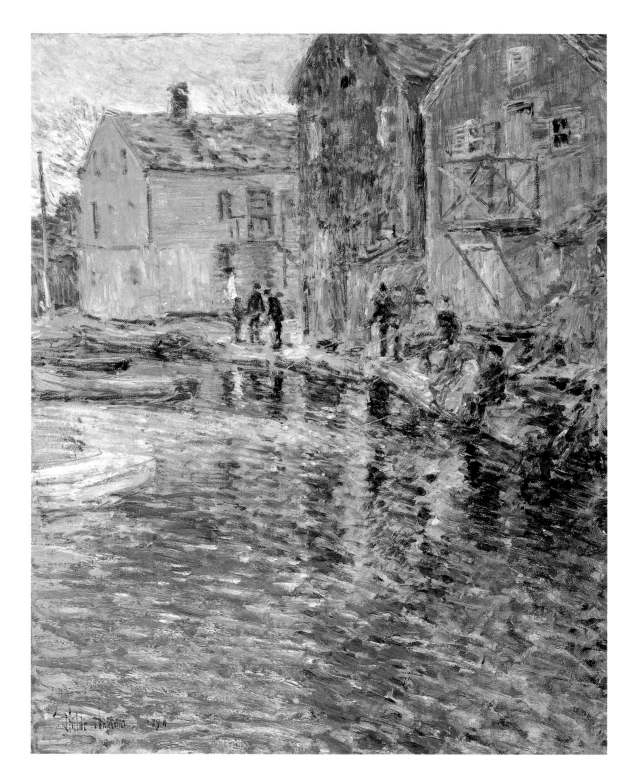

18.
Frederick Childe Hassam (1859–1935)
The Smelt Fishers, Cos Cob, 1896
Oil on canvas
22 1/4 x 17 1/2 inches
The Fine Arts Museums of San Francisco,
Gift of Rawson Kelham to the Fine Arts
Museums of San Francisco, 1989

to art historian Susan Larkin, Twachtman's most significant contribution as an instructor was at Cos Cob.[14] He encouraged students to explore and interpret nature and specifically weather conditions, much as he himself was doing at the time in Impressionistic works such as *Snowbound* (cat. no. 54), one of the many views he painted of his home. Weir's adaptation of Impressionist techniques such as the daring use of light and shadow to innovative compositional structures is illustrated in the painting *Path in the Woods* (cat. no. 58).

Twachtman, an acerbic but enormously popular teacher, was the lynchpin in the development of Cos Cob. One of the most important artists to come work alongside him was his friend Theodore Robinson. Robinson, a former resident of Giverny and an acquaintance of Claude Monet, served as a conduit of French Impressionism for Twachtman. Twachtman's shorthand notation and ability to summarize and distill images, on the other hand, influenced Robinson's work.[15] Robinson's own interest in nautical subjects, as seen in *Low Tide* (cat. no. 47), was an integral part of his development at Cos Cob.

John H. Twachtman
and artists at Palmer & Duff's:
Elmer MacRae (far right),
John Twachtman (third from right),
c. 1897. Photograph courtesy
of the Historical Society of the
Town of Greenwich, Connecticut

Another major painter associated with the art colony at Cos Cob was Childe Hassam, who began visiting in 1894 and returned periodically until 1917. His *The Mill Pond, Cos Cob, Connecticut* (cat. no. 19), informed by vivacious brushwork and a daring composition, focuses on the repair and upgrade of the Mianus River Railroad Bridge in Cos Cob during the first decade of the twentieth century.[16]

Cos Cob's counterpart to Old Lyme's Griswold House was the Holley House (originally called the Holley Farm), opened in 1874 by Edward Payson Holley and his wife, Josephine, on their farm in central Connecticut.[17] The original boarding house experienced financial setbacks and was foreclosed upon in 1877. Undeterred, the Holleys rented a more modest boarding house in Cos Cob, the Holley House, which they purchased in 1884. Among the early visitors to the Holley Farm were Twachtman and Weir, who later became regulars at the Holley House. Numerous artists and writers boarded with the Holleys over the years. The segregation between artists and students that existed at the Griswold House was absent at the Holley House: "While many of the artists, writers and editors eventually acquired their own homes in Greenwich, most were

Holley House, Cos Cob, Connecticut, c. 1890. Photograph courtesy of the Historical Society of the Town of Greenwich, Connecticut

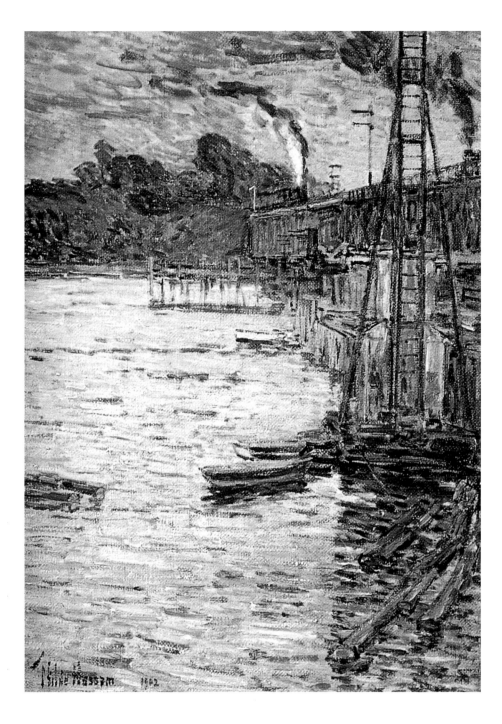

19.
Frederick Childe Hassam
The Mill Pond, Cos Cob, Connecticut, 1902
Oil on canvas
26 1/4 x 18 1/4 inches
The Bruce Museum,
Greenwich, Connecticut

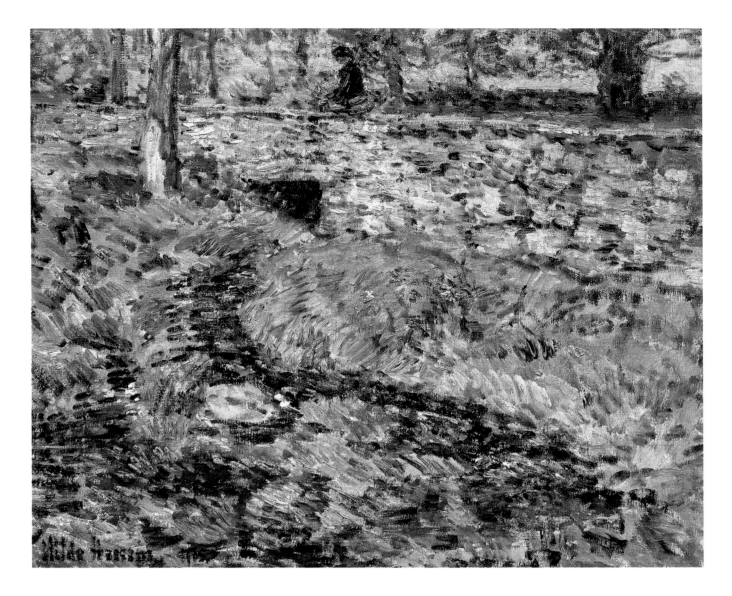

20.
Frederick Childe Hassam
Stone Bridge, Old Lyme, Connecticut, 1905
Oil on canvas
18 x 22 inches
San Diego Museum of Art
Gift of Gerald and
Inez Grant Parker Foundation

introduced to the town as boarders at the Holley House. The boarding house served as a live-in version of the European cafe...."[18] The house's traditions were maintained by the Holleys' daughter Constant, who married the artist Elmer MacRae in 1900. MacRae became an important figure in the Greenwich art community, and eventually one of the organizers of the Armory Show of 1913.

SHINNECOCK, LONG ISLAND

The explosion of growth on Long Island, particularly in Southampton, was also hastened by the railroad. Eastern Long Island is divided into two forks, north and south: the town of Southampton is found on the south fork. The Southside Railroad Line reached the east end of Long Island in 1868, essentially opening areas for the first time. With its improved accessibility, Southampton became a summer playground for wealthy New Yorkers who discovered its crystalline beaches and shore.[19] Likened to Newport, Rhode Island, by the 1890s it boasted a first-class hotel, the Shinnecock Inn, and the Shinnecock Hills Golf Club, the first incorporated golf course in America.[20] The area itself, called Shinnecock Hills, was especially noted for its location directly to the west of the village of Southampton.

One condition that was significant for the success of an art colony was a summer school.[21] Shinnecock was home to perhaps the most famous summer school of the period: William Merritt Chase's Shinnecock School of Summer Art, established in 1891. The art colony at Shinnecock differed from those at Old Lyme, Cos Cob, or Laguna Beach, because the overwhelmingly single attraction was Chase himself. At the urging of Mrs. William Hoyt, a wealthy summer resident of Southampton and an amateur artist, Chase was persuaded to become director of a summer art school at Shinnecock Hills. Two philanthropic Southampton residents, Mrs. Henry Kirke Porter and Samuel L. Parrish, donated the land and facilitated the construction of a studio building and residential cottages, dubbed the Art Village. The Art Village was the nucleus of the social life for the colony. Students rented a cottage or found alternative accommodations in neighboring boarding houses. By the second year, Chase was accorded the privilege of having a home a short distance from the village designed for him by Stanford White's firm.[22] *The Chase Homestead, Shinnecock* (cat. no. 6) is one of the many excellent representations the artist painted of his family home in the Shinnecock Hills.

A plunging road leads into the painting. Chase's daughter Dorothy, painted with an economy of strokes, picks flowers by the side of the road. From this vantage point, Chase essayed the solitary house and grounds in an Impressionistic manner, with swift brushwork and an infusion of light.

Much has been written about Chase, his dynamic personality, pedagogical prowess, and biting wit. About a thousand students studied with him during his summers in Shinnecock between 1891 and 1902. Town residents followed the school's events as well, attending his weekly critiques, open studio visits, and talks on art. Most of the students were amateur women painters, but a number of Shinnecock students later established successful careers as professional artists. Edmund Greacen, for example, an alumnus of the Chase summer school, was a resident in the art colonies at Giverny and at Old Lyme.

As was the case for all the art colonies under discussion here, the focus at Shinnecock was clearly on Impressionism— on light, spontaneity, and high-key chromatics, all brought to bear on the landscape. Students could be found painting in the fields from morning to night—to the bewilderment of the local farmers.[23] Truth to nature, the obligation of the painter to paint what he saw, was a standard by which Chase judged himself and his students.

Chase House, Shinnecock Hills, Long Island, c. 1895. Photograph courtesy of the William Merritt Chase Archives, The Parrish Art Museum, Southhampton, New York

21.
Frederick Childe Hassam
Clarissa, 1912
Oil on canvas
24 x 22 inches
The Historical Society of the
Town of Greenwich, Connecticut

66

22.
Anna Hills (1882–1930)
High Tide, Laguna Beach, 1914
Oil on canvas
20 x 30 inches
Private Collection
Photograph courtesy of DeRu's Fine Arts,
Laguna Beach, California

The spread of the railroads in nineteenth-century America ignited the interests of real estate speculators, who sought out picturesque locations on both coasts for economic development. While, like its Eastern counterparts, Laguna Beach was permanently affected by the expansion of the railways, it was still not nearly as accessible as these other towns were. The Santa Fe Railway arrived in Los Angeles in 1885 and within two years the line extended to San Diego. Passengers bound for Laguna Beach could get off at the El Toro stop (in the present-day city of El Toro), and take a stagecoach through the twisting canyons to Laguna Beach. The trip by stagecoach was not easy. Hills, dirt, mud, even "critters" went along with the lack of a decent road. Furthermore, the stage was available regularly only during the summer months, generally from the Fourth of July through Labor Day. The rest of the year it made the trip only once a week. Consequently, until the turn of the century, Laguna maintained a geographic insularity that was not shared with other art colonies.

Laguna Beach and its environs, from Laguna Canyon Creek to Three Arch Bay, was not included in the early land grants from the Spanish and the Mexicans that the Moulton and Irvine families later owned. In 1850, when California achieved statehood, the territory that had not been granted became open to homesteaders. Homesteading began in Laguna during the 1870s and was completed by the 1880s.[24] The 1880s was a period of economic boom in Southern California, but by 1889 the tide had turned radically, and, exacerbated by a national depression in 1893, nearly all of the original homesteaders were forced to sell their holdings.[25]

Laguna lore has it that the Los Angeles–based artist Norman St. Clair (see cat. no. 51) "discovered the colony" in 1900.[26] While St. Clair was in Laguna by the turn of the century, and was a catalyst for other artists to visit, he was not the first artist to succumb to the charms and pitfalls of life in Laguna. Several others preceded St. Clair, including Charles Walter Stetson (1858–1911), who visited in August 1889 and wrote letters to his parents describing the rather primitive conditions.[27]

Nevertheless, the beginning of the twentieth century also marks the beginning of Laguna Beach as an art colony. It was the site of individual summer classes possibly as early as 1903, although it did not have a formal, continuously operating summer school. A 1923

newspaper article states that "Mr. Judson [William Lees], when an instructor in the department of fine art... some twenty years ago, used to bring his summer classes to Laguna, where the charms of the village afforded an opportunity for an outing as well as for sketching."[28] Judson himself produced some masterful works in Laguna, such as *Bluebird Canyon, Laguna Beach* and *Temple Hill, Laguna Beach* (cat. nos. 27, 30). James McBurney, an artist who taught in Los Angeles during the second decade of the twentieth century, brought a sketching class to Laguna in 1912. Anna Hills, a resident beginning in 1913, taught summer classes during the teens. William Cahill, an artist who ran an art school in Los Angeles during the teens, offered summer classes in 1918. By the 1920s a number of artists were holding summer classes in Laguna, including Karl Yens (see cat. no. 68) and Clarence Hinkle (see cat. nos. 23–25), who was teaching during the summer months under the aegis of the Chouinard School of Art.[29]

Summer classes attracted a cross-section of individuals to Laguna: the amateur, the aspiring artist, and the professional painter. The summer's labors often resulted in an exhibition, as was the case for McBurney's class in 1918, who had a show at the Walker Auditorium in Los Angeles that September. Included were figure studies by Mabel Alvarez, who became a noted painter in Southern California.[30] Summer classes brought tourism and revenue to the city, forcing Lagunans to confront nagging issues. The town began experiencing distinct growing pains in the early teens. In 1917 Laguna had a little more than 275 residents (not including those living in Arch Beach).[31] Telephone service was not introduced until 1923.[32] Water, the most critical commodity, was expensive and difficult to obtain. Pacific Coast Boulevard (now Pacific Coast Highway), Laguna's main artery and access route, opened only in 1926, to both celebration and dissent. Nevertheless, when the city was incorporated in 1927, the population had mushroomed to 1900. By comparison, Los Angeles, just fifty miles north of Laguna Beach, was one of the first cities to benefit from modern technology, including electric lights, telephones and automobiles, and "more miles of graded streets than any comparably sized city in the world."[33]

As Laguna grew, local opinion was polarized on many issues, including real estate development, incorporation, and general civic improvements. The Chamber of Commerce, whose driving force was

23.
Clarence Hinkle (1880–1960)
Thoughts, c. 1915
Oil on canvas
36 x 30 inches
The Redfern Gallery,
Laguna Beach, California

24.
Clarence Hinkle
Beach Scene, c. 1925–30
Oil on canvas
18 1/4 x 22 1/4 inches
George Stern Fine Arts,
West Hollywood, California

the real estate interests, saw tremendous commercial potential for the city. In 1921 a film about Laguna Beach was previewed by 10,000 delegates at a realtors' convention in Chicago. Organizers additionally had eighty boxes of oranges, representing "Orange County," thrown from the pitcher's mound at a Chicago Sox baseball game.[34] An editorial in the local tabloid, *Laguna Life*, suggested that "any investment made in our community at this time is not only evidence of good judgment in property values, but assures the investor a profitable

Anna Hills, c. 1925.
Photograph Laguna
Art Museum Archives

25.
Clarence Hinkle
Overlooking Laguna, c. 1925–30
Oil on canvas
30 x 36 inches
Mr. and Mrs. Thomas B. Stiles II

return."[35] Other citizens expressed the need for caution and due diligence in matters concerning growth, concluding that hasty choices could result in disastrous repercussions.[36]

Artists actively voiced their opinions in the press. Anna Hills, in a letter to the editor, articulated a moderate viewpoint:

> *It is very difficult to put into words my ideals concerning the growth and future development of Laguna Beach.... The eight years I have been here have brought many changes to the little village. Most of them are for the better. The boulevard has come so that we no longer skid through slippery mud, mile after mile, as we used to do during the rainy season getting in and out of town. We needed the good roads and we still need more of them. The proposed coast boulevard will be an asset to Laguna....*[37]

Other residents, such as Alice V. Fullerton, strongly opposed any hasty development of the town: "How many property owners or visitors would come here if this beach had all the earmarks of a city—or of other beaches?"[38]

As early as the late teens or early twenties, Laguna was well aware of its reputation as an artists' colony. Business interests considered how to parlay the aura of an "art colony" into a financial windfall:

> *The artists' colony of Laguna Beach is the greatest asset the town possesses when it comes to making the place known to the outside world. I speak from the standpoint of a publicity woman who sees in terms of interest to the world as a whole. Of course the scenery of Laguna Beach is the drawing card for artists, and it is also the drawing card for thousands of visitors, but even if the scenery were eliminated and the artists left, the thousands would still come because there is, and always has been, an atmosphere of romanticism and charm surrounding an artists' colony that is unlike any other thing in the world....I am well aware of the fact that the artists do not want to be advertised and that anything that savors of publicity is offensive to the majority of them, but I contend that they boost any place where they may choose to settle and that they do have a wonderful advertising value to that place and that the value becomes a commercial asset with or without the consent of the artists.*[39]

A seemingly minority faction believed that the business community was merely supporting a group of parasitic artists. To those detractors, one commentator firmly responded:

What the artists do for the town, even if they do nothing else, is to attract to us the sort of people who are most desirable; and their work, going out from Laguna all over the country is certainly publicity of a higher class than any other community of this size in Southern California is able to put out.[40]

A major consideration was how to keep the most precious aspects of Laguna's geographical integrity intact, while still allowing the town to grow. In 1922 an editor for the *Christian Science Monitor* wrote a pleasant, if not flattering, account of Laguna Beach. He acknowledged the importance of the art colony; he recognized the unique qualities of the landscape. He also described it as a "sleepy little village," comprised of a "mere handful of dwellings and rather primitive stores."[41] The editorial response from *Laguna Life* was swift and cutting:

Our "handful of dwellings" cover an area of many blocks and our "primitive stores" are located on three business streets, paved and sidewalked. Our commercial institutions represent every line of trade with the exception of one or two which might be justly termed as luxuries, and our merchants carry stocks that compare favorably with those in the larger cities. The Monitor pays a merited tribute to our artist colony, of which we are duly proud, but back of the artistic impulse and environment which distinguishes Laguna and has set it apart as the "beach that is different," there is a constructive element which is the basis of constant effort along the line of progress and improvement.[42]

It is fair to conclude that in spite of their disparate views, the artists, residents, and business community had a symbiotic relationship. Artists wanted to live in Laguna Beach and the residents appreciated their presence. Ultimately it was this understanding that helped foster the growing community.

26.
Wilson Irvine (1869–1936)
Lois, c. 1914
Oil on canvas
27 x 24 inches
Spanierman Gallery, LLC, New York

One of the major differences between the colony at Laguna and other colonies was where artists lived once they arrived. Artists who came to Laguna in the earliest part of the twentieth century did not gravitate toward one central hotel or boarding house, although many artists drawn to colonies saw themselves as a "clubby breed."[43]

Hubbard Goff built the first hotel in the area in Arch Beach during the mid-1880s (Arch Beach and Laguna Beach were separate communities). By 1886 Henry Goff, Hubbard's brother, had opened a hotel in Laguna Beach. Nonetheless, the most popular spot for tourists was on the beach itself in "tent cities." Residents from as far away as Riverside and Santa Ana literally pitched tents by the shore to escape the summer heat in the cities, thereby obtaining free accommodations.[44]

An earlier watershed for Laguna Beach had been the arrival of Joseph Yoch, his wife, Kate Isch Yoch, and their family in 1888. Yoch, originally from Illinois, was one of the first wealthy individuals to settle in Laguna. Recognizing the need for reasonable lodging, Yoch financed the Brooks Hotel, built in downtown Laguna in 1893, but it was destroyed by fire almost immediately after opening.[45] When the Goff brothers' establishments fell victim to economic decline in the

Laguna Beach Hotel, Laguna Beach, California, c. 1913. Photograph courtesy of Jane Janz

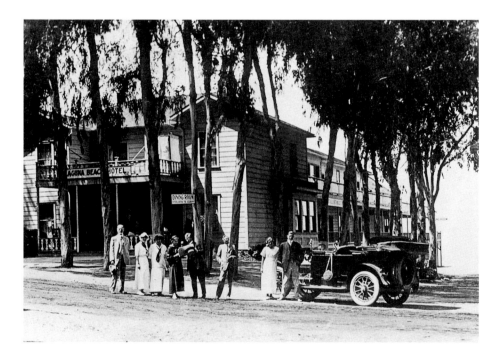

27.
William Lees Judson (1842–1928)
Bluebird Canyon, Laguna Beach, c. 1912
Watercolor
17 x 22 inches
Joan Irvine Smith Fine Arts, Inc.,
Laguna Beach, California

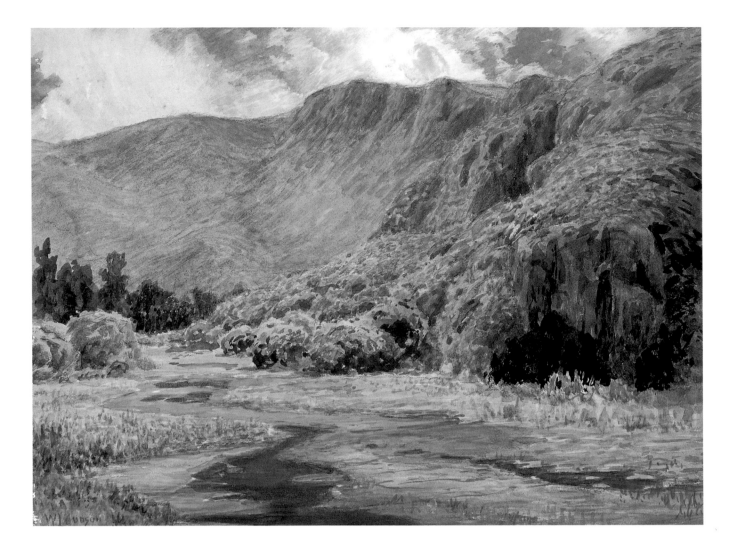

78

28.
William Lees Judson
Early Spring, Laguna Beach, c. 1912
Watercolor
17 x 22 inches
Joan Irvine Smith Fine Arts, Inc.,
Laguna Beach, California

1880s, Yoch purchased them. Faced with the high cost and difficulty of obtaining lumber in Laguna, he literally brought both hotels together by cutting up one structure and joining it to the other, thus creating the Hotel Laguna in the late 1890s. To ensure the hotel's success, he invited the wealthy and famous to Laguna, even providing exclusive transportation for hotel visitors. Joseph Kleitsch's *Hotel Laguna* (cat. no. 35) is a wonderful image of this Laguna landmark.

While the Yochs were great supporters of the town's artist population and opened their hotel to art exhibitions (for example, Norman St. Clair had an exhibition there in 1906), the Hotel Laguna was not a magnet for artists in the same way as the Holley House or Griswold House.[46]

Where artists stayed during these early years must be pieced together, since there are no extant records. By 1906 there was a boarding house in Laguna called the Breakers, which operated primarily during the summer. Acccording to a newspaper account, William Swift Daniell (see cat. no. 10) held a one-person exhibition there in 1906, and he may have resided there as well, though another report states that he rented a cottage on the beach for himself and his family.[47]

Several artists rented cottages and rooms from local residents. William Lees Judson's summer students were "domiciled in the old Yoch cottages—picturesque landsmarks of pioneer days.[48] In addition to the hotel, the Yoch family owned rental cottages at the beach. Frank Cuprien and others rented rooms from local residents before building their own studios. One woman recalled that in approximately 1914, she "stopped at a house with a lovely verandah overhanging the water. A hospitable woman came and took us in out of the rain, into a harming large room and then downstairs to the studio of one Cuprien, whose pictures of the sea and the cliffs of Arch Beach she showed us."[49] J.N. (Nick) Isch, proprietor of the general store, post office, and livery stable, and brother-in-law to Joseph Yoch, owned the most famous cottage of the period, appropriately named the Paint Box. When it succumbed to fire in 1926, the notice stated: "The Paint Box went up in flames last Monday night, and with it the aura of romance that has enveloped it since its building twenty-two years ago by Nick Isch. The place has been the home of more famous celebrities than any other house in Laguna Beach. It has always been the Mecca for the artistic and literary set because of the folks within its walls."[50] The Paint Box housed many artists over the years, including

Norman St. Clair, Emily White, Donna Schuster, Edgar Payne, Mabel Alvarez, and the photographer George Hurrell. James McBurney, who was teaching a group of eight women in Laguna during the summer of 1912, rented the cottage.[51] In all probability, Isch bartered food and lodging for paintings, for his collection, according to a 1911 newspaper report, included works by "Elmer Wachtel, Gardner Symons, Hanson Puthuff, Edward [sic] Payne, Norman St. Clair, Nona White and William Griffith...."[52]

The Yoch hotel and the Isch general store are often cited as Laguna's social gathering spots. Considering that two of the three phones in town were located in the hotel and general store, which was the only place to buy groceries and receive mail, it is not surprising that people congregated there. Nevertheless, neither the fraternitylike atmosphere of Cos Cob or Old Lyme, nor the insularity of Shinnecock's Art Village existed in Laguna Beach during the early twentieth century.

Still, artists came to Laguna and actively sought out each other's company. Norman St. Clair urged Granville Redmond to visit Laguna, and the two painted there in 1903. Joining them that year were Elmer Wachtel and Gottardo Piazzoni. Gardner Symons purchased property in Arch Beach in 1903, and may have visited Laguna prior to this date.[53] He enticed his friend William Wendt to visit, and, according to an article, they spent three months sketching and living in "an abandoned farmhouse in Laguna Canyon."[54] The same article notes that Symons persuaded William Swift Daniell to come to Laguna, which he did with his wife in 1905. Nona White, whose sister Emily White was a resident artist in Laguna, was known to have "wintered here" in 1907.[55] In fact, by 1907 Antony Anderson, the critic for the *Los Angeles Times* (who became a part-time resident of Laguna Beach in 1921), claimed that artists such as William Lees Judson, Edith White, and Hanson Puthuff had also visited Laguna.[56] In 1908 Conway Griffith was living in Arch Beach, and later established a studio on Glenneyre Street: "The quaint studio of Conway Griffith...is a much visited place during these summer days. Mr. Griffith keeps genial open house, and when there is no more room for guests in the studio proper the 'waiting list' occupy chairs in the attractive ramada."[57] Frank Cuprien arrived in Laguna in 1912, where, according to his recollections, he had "come to spend a day in the village of which I had heard so much. Reports of its charm had not been exaggerated, I decided that day."[58] Cuprien's first studio was on Catalina Island before he moved to Laguna and built a studio dubbed "The Viking."

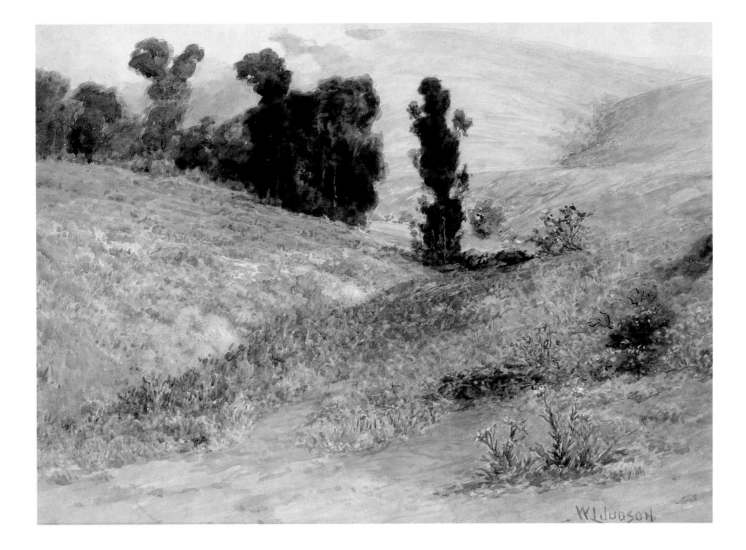

29.
William Lees Judson
Sleepy Hollow, Laguna Beach, c. 1912
Watercolor
17 x 22 inches
Joan Irvine Smith Fine Arts, Inc.,
Laguna Beach, California

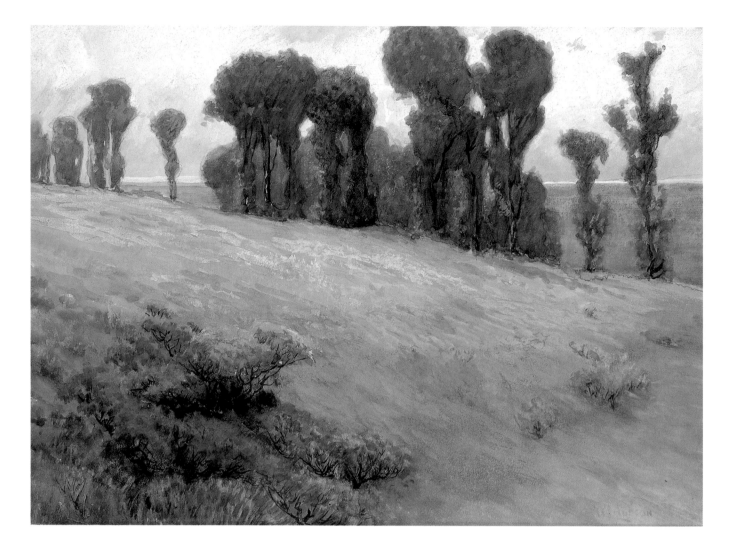

30.
William Lees Judson
Temple Hill, Laguna Beach, c. 1912
Watercolor
17 x 22 inches
Joan Irvine Smith Fine Arts, Inc.,
Laguna Beach, California

The artists who visited and ultimately stayed in Laguna would have found communal living impractical for their pictorial agendas. Southern California Impressionist painters did not practice a "typical" Impressionism, either thematically or stylistically.[59] William Gerdts has stated that "California Impressionists did not remain committed to a single aesthetic and some veered away from traditional Impressionist practice, though many of them reiterated certain landscape and figurative themes."[60] Certainly they did share points of affiliation with their Eastern counterparts, especially in their preoccupation with landscape painting, however, artists painting in Laguna Beach were not interested in the cultivated landscape of residences and home gardens that attracted Eastern painters. Art historian Lisa Peters has stated that "American Impressionists portrayed a kind of accessible nature... [they] portrayed homes from close-up vantage points and depicted the world they found by looking out of their front and back doors and by standing in their gardens and in those of their neighbors.[61] Scenes such as George Burr's *Old Lyme Garden* (cat. no. 4), painted on the grounds of his home in Connecticut, or Edmund Greacen's *The Old Garden* (cat. no. 16), depicting Florence Griswold's garden in Old Lyme, substantiate that observation. The old-fashioned "Grandmother's garden," a symbol

Frank Cuprien's Viking Studio, Laguna Beach, California, c. 1920s. Photograph courtesy of Jane Janz

of home and hearth, had become a pictorial metaphor for traditional values and family life in the early twentieth century. Many American Impressionists cultivated their own informal gardens, which were then used as models in their works.[62]

Domesticated gardens were at a premium in the Laguna area during this period; the terrain was rugged and uncultivated. The natural landscape offered a colorful alternative: poppies, lupines, bougainvillea, and wildflowers of all sorts populate California Impressionist painting. Works such as Granville Redmond's astounding landscapes of the poppies and lupines that blanket California hillsides in the spring, including *Silver and Gold* (cat. no. 46), were not executed in a domestic setting. William Griffith's *In Laguna Canyon* (cat. no. 17) and William Wendt's *Twilight* (cat. no. 60) were painted on treks into the canyons and foothills. Painters often spent days camping out, in less than favorable conditions, to accomplish these scenes:

> *If you think the life of the successful landscape painter is one long paean of joy, prepare to modify your opinion.... Every landscape painter must prepare to be a pack mule— strong, stubborn, unbreakable as to arms, legs and back. Consider the things he must carry under a broiling sun, three, six, or even nine miles up hill and down dale, through brush, over rattlesnakes and tarantulas. A huge stretched canvas, a big easel, a bigger umbrella and a heavy box of paints, many brushes, a palette.... The painter shoulders it without a murmur, and after three hours of tramping sits joyfully down...and proceeds to paint a masterpiece or something not quite so good. I tell you, our landscape painters are our heroes, men of iron!* [63]

The commitment to recording uncultivated locales, to examining grandiose vistas, required an independent and self-sufficient individual, more content with the company of nature than the company of others. Will South has noted that in many ways the mantle of the Hudson River School painters, in terms of recording grandiloquent landscapes replete with moral and religious underpinnings, was assumed by many California Impressionist painters.[64] For Hudson River School painters, the majestic landscape, ancient and enduring, offered validation for a country that was politically and socially

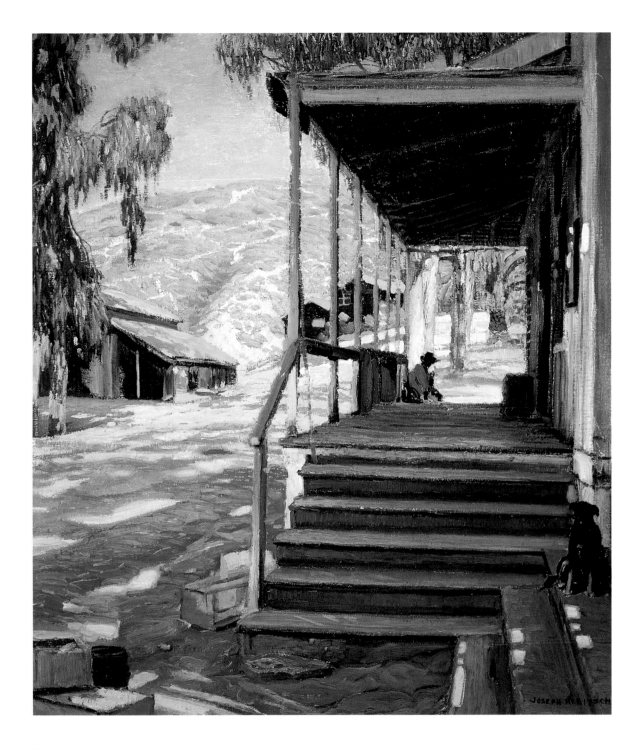

31.
Joseph Kleitsch (1882–1931)
The Old Post Office, c. 1922–23
Oil on canvas
40 x 34 inches
Laguna Art Museum/Orange County
Museum of Art Collection Trust,
California, Gift of the Estate of Joseph
Kleitsch in Memory of His Wife Edna

32.
Joseph Kleitsch
Old Laguna, c. 1922–25
Oil on canvas
18 x 21 inches
The Redfern Gallery,
Laguna Beach, California

immature. The unspoiled Southern California landscape offered significance to a newly born state, with its nascent communities.

Although landscape was the dominant theme, not all artists working in Laguna were completely dedicated to it. Artists depicted various subjects, including seascapes, still lifes, and portraits. Joseph Kleitsch, for example, who arrived in Laguna in 1920, was a multi-faceted artist.[65] Unlike the majority of California Impressionists, Kleitsch enthusiastically painted the town of Laguna in such works as *The Old Post Office, The Green House,* and *Laguna Beach* (cat. nos. 31, 33, 36). His renditions of Laguna are decidedly unsentimental, and reveal ramshackle buildings and unpaved roads, set against the backdrop of the hills. These scenes do not reflect the political and social battles unfolding within the town that would soon impact on this unspoiled vision. Almost concurrent with Kleitsch's arrival, Laguna began to enter a rapid period of growth.

One of the most dedicated of pure landscape painters, William Wendt was drawn to Laguna's enduring charm. William Gerdts has characterized Wendt (along with Guy Rose) as one of the "two most significant and original painters in Southern California

Artists in Laguna Beach, California, c. 1918: Guy Rose (third from left, back row), Donna Schuster (front left). Photograph courtesy of Charlotte Braun White

in the first three decades of the twentieth century."[66] Wendt was at the epicenter of Impressionism's ascendency in Southern California. He was the brightest star in the constellation of the California Art Club, Los Angeles's most powerful force promoting Impressionism during the early teens. In spite of his connection to Los Angeles, and to other major cities where his work was exhibited, Wendt preferred the quiet life of Laguna. He has been described as something of a recluse, but this may be a stilted characterization.[67] His trademark became a thick, blocky Impressionist brush stroke that he used to construct and pattern his canvases.

The *Overton Cottage and Old Highway* and *Seaside Cottages* (cat. nos. 63, 65) are two quite different views of Laguna Beach. Wendt created several images of the coast road before its incarnation as the Pacific Coast Boulevard in 1926. This gentle, serpentine stretch, punctuated by cottages and groves of eucalyptus trees, became a bone of contention during this period. The new road, which linked Newport Beach and San Juan Capistrano, was built in sections throughout the 1920s. Its completion signaled a line of demarcation in Laguna's history. The following year the city incorporated (having waited until the road was finished so that the county would assume the financial burden),[68] and the improved accessibility brought increased development, traffic, and commerce to the area.

Seaside Cottages was a departure for Wendt. Painting from above in his studio, Wendt looked down and chronicled the cottages and roads, using patterns and shifts in viewpoint to create a rich visual puzzle. That the artist could take a pedestrian subject, cottage rooftops, and make it pictorially engaging, was remarked by contemporary critics: "As far as life and letters go, it's an old story that it does not matter what you do but how you do it. And it is equally true about painting. Anyone who can take a group of nondescript, unlovely summer shacks perched on a steep hill in sight of the ocean and make a seaside epic, well that's painting."[69]

While artists working in the Connecticut colonies and Shinnecock generally avoided painting pure seascapes, few painters in Laguna ignored the ocean's allure. Frank Cuprien, who achieved a sort of mythical status among Laguna painters, was among the early artists devoted to seascapes. Known as the "dean of the art colony," he played an active role in the community during his many years as a resident. *Poème du Soir* (cat. no. 7), although a typical subject, was

33.
Joseph Kleitsch
The Green House, 1930
Oil on canvas
36 x 40 inches
Joseph Ambrose, Jr.

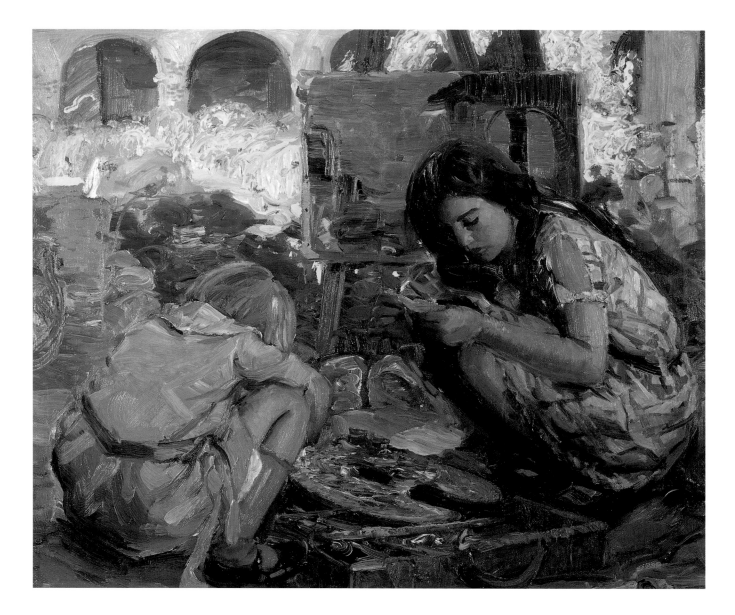

34.
Joseph Kleitsch
Curiosity, c. 1923–24
Oil on canvas
25 x 30 inches
Mr. and Mrs. Thomas B. Stiles II

a departure stylistically for the artist. Cuprien's seascapes generally are tightly constructed and fairly traditional in their treatment of water and sky. This work is much more Impressionistic in its conception. Yellow, the dominant hue, is used to describe both the sea and sky in the background; shades of purple punctuate the horizon line and breaking waves. The color is applied in large sections, creating patterns and contrast.

Other artists responded to the proximity of the sea. In Gardner Symons's *Under a Blue Sky* (cat. no. 52), the artist interpreted the kinetic forces of the ocean with broad painterly strokes, forcefully applied, to imply the power of the waves breaking against the rocks. A more subdued vision is presented by Guy Rose in *Laguna Shores* and *Laguna Rocks, Low Tide* (cat. nos. 48, 49). A frequent visitor, although never a resident, Rose loved Laguna's coastal weather and haunting landscape.

Given the steady increase in the number of artists working in separate studios by the end of the teens, it is not surprising that establishing an art association in Laguna with an exhibition gallery became a priority. Many precedents existed for this. Members of the colony at Old Lyme began to exhibit together as a group as early as 1902. In 1914 the Lyme Art Association was founded and the Lyme Art Gallery opened seven years later.[70] At Cos Cob the Greenwich Society of Artists was established in January 1912, and the society's first annual exhibition of painting and sculpture was held in September of that year.[71] Although Shinnecock had no actual association, there were exhibitions of students' work during the summer, and occasionally those shows traveled to cities such as New York or Philadelphia. In many ways art associations were natural outgrowths of colonies and the need for artists to have convenient exhibition venues.

The Laguna Beach Art Association was officially established in 1918. The drive was spearheaded by Edgar Payne, who moved to Laguna Beach in 1917 with his wife, Elsie (see cat. no. 43).[72] Payne galvanized the community of established artists, including Frank Cuprien, Anna Hills, Gardner Symons, and William Wendt, along with others, to form an alliance. Payne sought to create a nucleus for the colony. The first step was to establish an art gallery. The abandoned community house was judged an appropriate site, and with monies collected from artists and local individuals, repairs were made to the building. Frank Cuprien recounted:

was Open House at the Gallery. Lagunans groped their way down the narrow dark streets, lighted lanterns in their hands. On cold nights they brought their own oil stoves. Even on the stormiest of nights a few of us ploughed through the mud, stoves and lanterns in our hands, and kept the Gallery going in case anyone should wander in. We were determined to keep it going; we knew what it would mean to the future of the town.[76]

Keeping the gallery alive allowed for the even greater achievement that was to come in 1929. During the 1920s, as the Art Association grew, the need for another building, a fireproof structure, was apparent. Private funding efforts were made to secure a new building. On February 16, 1929, the Laguna Beach Art Association became the first venue in Southern California built solely for exhibiting painting and sculpture.

As the bastion of California Impressionism, Laguna Beach stood alone as a colony in Southern California in the early twentieth century. Its closest analogues were in Monterey and Carmel, the two art colonies just outside the Bay Area that flourished in the wake of the 1906 earthquake. Although the dominant aesthetic in the Bay Area was Tonalist, several Impressionist painters, such as Evelyn McCormick, John Gamble, Mary DeNeale Morgan, and E. Charlton Fortune, were active on the Monterey Peninsula. In fact, it was Fortune who invited William Merritt Chase to Carmel in 1914, where he taught summer classes.[77]

In spite of shared interests, however, there was little exchange between artists in Laguna and Monterey and Carmel, with the exception of Donna Schuster, who studied with Chase during the summer of 1914 and maintained a studio in Laguna, and the ubiquitous Guy Rose. Geographic distances were a contributing factor, but even artists who lived in colonies geographically nearby, such as Old Lyme, Cos Cob, Shinnecock, and elsewhere, tended to maintain a strong allegiance to one particular place (Childe Hassam notwithstanding). There was even a certain rivalry between camps, for example, among the summer students of Twachtman in Cos Cob and Chase's group in Shinnecock.[78] Although several artists also painted in East Coast colonies—Charles Reiffel at Silvermine, Connecticut; Alson Clark at Old Lyme; and Guy Rose in Connecticut—with the exception of Rose, there was little movement between artists in Laguna Beach and the East Coast.[79]

36.
Joseph Kleitsch
Laguna Beach, 1925
Oil on canvas
16 x 20 inches
Michael D. Feddersen

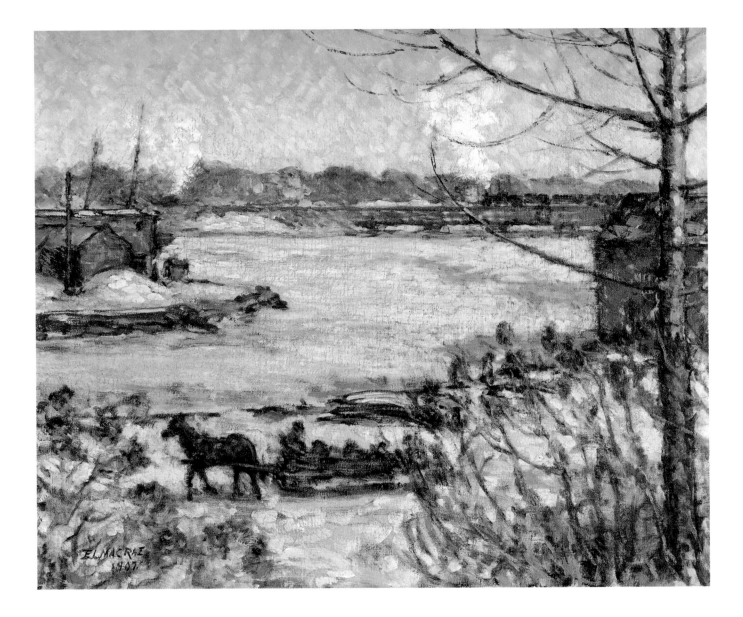

37.
Elmer MacRae (1875–1953)
Railroad Bridge, Winter, 1907
Oil on canvas
22 x 27 inches
The Bruce Museum,
Greenwich, Connecticut

Laguna Beach remained significant as a colony far longer into the century than others. That was due, in part, to the fact that Impressionism ran its course longer in Southern California than in the East: it was still the dominant aesthetic in Laguna even into the 1930s. Although Impressionism was firmly ensconced in Los Angeles with the birth of the California Art Club in 1909, the roster of artists who were active in the club reads like a "who's who" of those who either lived or worked in Laguna Beach, including Benjamin Brown, Frank Cuprien, Anna Hills, Clarence Hinkle, Edgar Payne, Hanson Puthuff, Guy Rose, Donna Schuster, Jack Wilkinson Smith, Karl Yens, and William Wendt (the club's president). Los Angeles, with its many galleries and dealers, may have been the financial heart of Impressionism, but Laguna Beach was its soul.

By the 1920s the importance of both Cos Cob and Old Lyme as art colonies had diminished; Shinnecock's significance ran concurrent with the school's longevity. Artists in Laguna Beach, however, remained committed to keeping the colony viable. It remained significant as a colony in spite of the explosive aesthetic changes that have characterized the art of the twentieth century. Although conditions in Southern California were ripe in the beginning of the century for the practice of Impressionism, its overall development and success would have been dramatically altered without the community of artists who lived and worked in the seaside haven of Laguna Beach.

1. Neeta Marquis, "Laguna: Art Colony of the Southwest," *International Studio* 70 (March 1920), p. 26.

2. "Thousands of Art Lovers from All Parts of the World Visit Laguna Beach Gallery Annually," *The Woman's Star* 4 (August 1924), p.1.

3. For a discussion of the evolution of art colonies, see William H. Gerdts, "East Hampton, Old Lyme and the Art Colony Movement," in *En Plein Air* (East Hampton, New York: Guild Hall of East Hampton; Old Lyme, Connecticut: Old Lyme Historical Society, 1989), pp. 13–16.

4. Karal Ann Marling, *Woodstock: An American Art Colony, 1902–1970* (Poughkeepsie, New York: Vassar College Art Gallery, 1977), unpag.

5. Jeffrey W. Andersen, "The Colony at Old Lyme," in *Connecticut and American Impressionism* (Storrs, Connecticut: William Benton Museum of Art, 1980), p. 114.

6. Jeffrey W. Andersen, "A Season in Lyme: Life Among the Artists," in *En Plein Air* (note 3) p. 27.

7. Ibid., p. 30.

8. For an account of Miss Florence's boarding house, see Andersen (notes 5, 6).

9. Andersen (note 5), p. 124.

10. Ibid., pp. 130–31.

11. Susan Larkin, "The Cos Cob Clapboard School," in *Connecticut and American Impressionism* (note 5), p. 83.

12. Susan Larkin, "'A Regular Rendezvous for Impressionists': The Cos Cob Art Colony, 1882–1920," Ph.D. dissertation, City University of New York, 1996, p. 157. In discussing how artists reacted to the juxtaposition of technology within the landscape, Larkin invokes Leo Marx's theme of the "machine in the garden"(p. 147). The author would like to thank Susan Larkin for her valuable advice regarding artists active in Cos Cob during the turn of the century, and for her thoughtful reading of this manuscript.

13. Ibid., pp. 17–18.

14. Ibid., p. 41.

15. Larkin (note 11), p. 91.

16. Larkin (note 12), p. 157.

17. For an excellent account of the history of the Holley House, see ibid.

18. Ibid., p. 46.

19. Katherine Cameron, "The South Fork: Southampton, Shinnecock Hills and William Merritt Chase," in *The Artist As Teacher: William Merritt Chase and Irving Wiles* (East Hampton, New York: Guild Hall Museum, 1994), p. 23.

20. D. Scott Atkinson, "Shinnecock and the Shinnecock Landscape," in *William Merritt Chase, Summers at Shinnecock 1891–1902* (Washington, D.C.: National Gallery of Art, 1988), p. 16.

21. Marling (note 4).

22. Nicolai Cikovsky notes that Chase's house was originally designed for another resident of Shinnecock, Charles L. Atterbury. See Nicolai Cikovsky, "Interiors and Interiority," in *William Merritt Chase, Summers at Shinnecock* (note 20), p. 45.

23. Ronald Pisano, *A Leading Spirit in American Art: William Merritt Chase, 1849–1916* (Seattle: Henry Art Gallery, 1983), p. 124.

24. The author is greatly indebted to Jane Janz of Laguna Beach, who shared her vast knowledge of Laguna history and made available important archival material from her personal collection.

25. Nancy Dustin Wall Moure, *Loners, Mavericks & Dreamers* (Laguna Beach, California: Laguna Art Museum, 1993), p. 44.

26. Janet B. Dominik, "Laguna Beach Art Association: 1918 to 1928," in *Early Artists in Laguna Beach: The Impressionists* (Laguna Beach, California: Laguna Art Museum, 1986), p. 10. See also Edan Milton Hughes, *Artists in California* (San Francisco: Hughes Publishing Company, 1988), p. 488. In an article in *South Coast News*, entitled "Why We Came To Laguna Beach," June 23, 1944, p. 1, Mrs. Norman St. Clair recounted the story of what brought her husband to Laguna: "While waiting my turn in an oculist's office in Los Angeles in 1900 a woman sitting near me asked where I was from. I said Los Angeles was my home and asked her where she came from. She said Laguna Beach, and described it as off the beaten track, a place where the trees grow down to the shoreline and the scenery beautiful. My husband, a professional architect, loved to paint and was always looking for new scenery, so I told him about Laguna Beach...."

27. This information is courtesy of Nancy Dustin Wall Moure, "The Laguna Beach Art Association— History to 1955—As Extracted from the Pages of the *South Coast News*," unpublished research, which Ms. Moure generously shared with the author. It has also been recounted that Isaac Frazee (1858–1942) came to Laguna in the late 1870s to camp and sketch. See Susan Anderson and Bolton Colburn, "Painting Paradise: A History of the Laguna Beach Art Association," in *Impressions of California* (Irvine, California: The Irvine Museum, 1996), p. 112.

28. *Laguna Life*, July 20, 1923, p. 14.

29. Karl Yens advertised in the May 1922 issue of *Laguna Life*. An advertisement for Hinkle's summer classes can be found in *Laguna Life*, July 28, 1922.

30. *Los Angeles Times*, September 7, 1918, sec. 3, p. 2.

31. As cited in Moure (note 27).

32. "Proposed Telephone Service," *Laguna Life*, June 29, 1923, p. 10.

33. Susan Landauer, "Impressionism's Indian Summer: The Culture and Consumption of Plein Air Painting," in *California Impressionists* (Irvine, California: The Irvine Museum, 1996), p. 42.

34. *Laguna Life*, July 15, 1921.

35. *Laguna Life*, June 6, 1922.

36. See *Laguna Life*, August 26, 1921.

37. Anna Hills, "Artist's Idea for Laguna Future," *Laguna Life*, July 29, 1921, as cited in Moure (note 27).

38. "Laguna Being Destroyed Says Miss Fullerton," *Laguna Life*, July 29, 1921.

39. Marion Munson Forrest, "Artists' Colony Is Greatest Asset of Laguna," *Laguna Beach Life*, June 26, 1925, p. 6.

40. *Laguna Life*, July 29, 1921.

41. "Laguna Beach Art Colony," *Laguna Life*, June 30, 1922.

42. *Laguna Life*, June 30, 1922.

43. Harold Spencer, "Reflections on Impressionism, Its Genesis and American Phase," in *Connecticut and American Impressionism* (note 5), p. 45.

44. Merle Ramsey, *Pioneer Days of Laguna Beach* (Laguna Beach, California: Hastie Printers, 1967), p. 21. Several books concerning local history are: Elizabeth Quilter, *Emerald Bay* (Laguna Beach, California: Elizabeth Quilter, 1977); Karen Wilson Turnbull, *Three Arch Bay* (Santa Ana, California: Friis-Pioneer Press, 1977); Jim Sleeper, *Orange County Almanac of Historical Oddities* (Trabuco Canyon, California: Ocusa Press, 1974).

45. According to Jane Janz, Yoch's primary residence was in Santa Ana, but he had a cottage in Laguna Beach. The author wishes to thank Janz for information on the Yoch family.

46. See *Los Angeles Times*, August 26, 1906, sec. 6, pp. 2–4.

47. "Story of Old Laguna Told," *South Coast News*, 1938, p. 5 : "In 1906 Mr. Daniell staged the first one-man show of his paintings in the main rooms of the fashionable boarding house, The Breakers, which stood back of the boardwalk where the Broiler café now stands." See also the contradictory statement in *South Coast News*, August 1946, p. 1 (courtesy of Jane Janz).

48. *Laguna Life*, July 20, 1923, p. 14 (courtesy of Jane Janz).

49. "Woman Writes of Laguna as it Was Forty Years Ago," *South Coast News*, June 1954 (courtesy of Jane Janz).

50. "Fire Guts Paint Box, Noted Studio of Many Artists," *Laguna Life*, March 5, 1926, p. 1 (courtesy of Jane Janz).

51. *Los Angeles Times*, August 4, 1912, sec. 3, p. 17.

52. *Los Angeles Times*, September 10, 1911, sec. 3, p. 24.

53. Information courtesy of Moure (note 27).

54. "Story of Old Laguna Told," *South Coast News*, July 8, 1938, p. 5, as cited in ibid.

55. Information courtesy of Jane Janz.

56. For information on Anderson's move to Laguna, see *Laguna Life*, September 2, 1921. For information on artists in Laguna, see Antony Anderson, *Los Angeles Times*, August 11, 1907, sec. 6, pp. 2–4. See citation in Moure (note 27).

57. *Los Angeles Times* (note 51).

58. Frank Cuprien, "Dean of Art Colony Arrives in Laguna for Visit, That Was a Quarter Century Ago," *South Coast News*, July 26, 1940, pp. 12–13.

59. For a comprehensive study of California Impressionism, see William H. Gerdts and Will South, *California Impressionism* (New York: Abbeville Press, 1998).

60. William H. Gerdts, "California Impressionism in Context," in ibid., p. 19.

61. Lisa N. Peters, "American Impressionist Views of the Home and Its Ground," in *Visions of Home* (Carlisle, Pennsylvania: Trout Gallery, 1997), p. 14.

62. See May Brawley Hill, "The Domestic Garden in American Impressionist Painting," in *Visions of Home* (note 61), pp. 53–54.

63. Antony Anderson, "Art and Artists," *Los Angeles Times*, October 5, 1913, sec. 3, p. 2.

64. Will South, "In Praise of Nature," in *California Impressionism* (note 59), p. 83.

65. For information on Kleitsch, see Patricia Trenton, "Joseph Kleitsch: A Kaleidoscope of Color," in *California Light, 1900–1930* (Laguna Beach, California: Laguna Art Museum, 1990), pp. 137–56.

66. William H. Gerdts, "Images of the 'Land of Sunshine': California Impressionism," in *All Things Bright and Beautiful* (Irvine, California: The Irvine Museum of Art, 1998), p. 44.

67. Landauer (note 33), p. 45. Jane Janz finds such a view to be unfair.

68. There was considerable discussion in the local paper as to who should pay for the road construction and when the city should incorporate. See also Moure (note 27).

69. Information courtesy of David & Sons Fine Art, Laguna Beach, California.

70. Gerdts (note 3), p. 21.

71. Larkin (note 12), p. 83.

72. For information on the inception of the Laguna Beach Art Association, see Janet B. Dominik et al., *Early Artists in Laguna Beach: The Impressionists* (Laguna Beach, California: Laguna Art Museum, 1986); Susan Anderson and Bolton Colburn, et al., *Impressions in California. Early Currents in Art, 1850–1930* (Irvine, California: The Irvine Museum, 1996).

73. Cuprien (note 58).

74. Dominik (note 26), p. 10.

75. See Moure (note 27).

76. Cuprien (note 58), p. 13.

77. For an in-depth review of Monterey and Carmel, see Will South, "California Impressionists At Home and Afield," in *California Impressionism* (note 59), pp. 160–68.

78. Larkin (note 12), p. 94.

79. One artist, Robert Dudley Fullonton, living in Laguna Beach by 1925, stayed at the Griswold House in Old Lyme. He apparently painted a panel for the dining room (as did many artists), but left without paying for his room. His panel was turned to the wall and another artist painted on the reverse. Information courtesy of Jack Becker, curator of the Florence Griswold Museum. The author would also like to thank Mr. Becker for his thoughtful reading of this manuscript.

38.
Elmer MacRae
Japanese Iris, 1914
Oil on canvas
24 x 20 inches
The Historical Society of the Town
of Greenwich, Connecticut

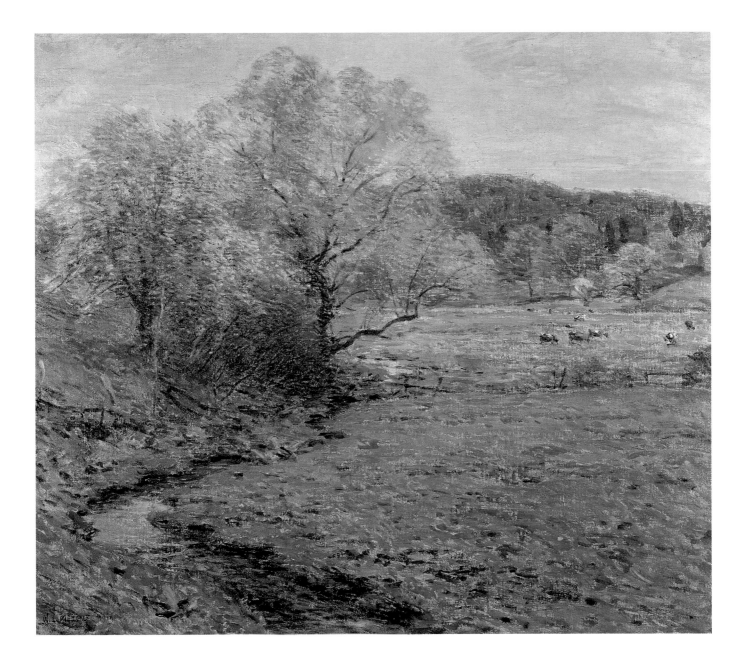

39.
Willard Metcalf (1858–1925)
The Green Meadow, 1919
Oil on canvas
26 x 29 inches
Lyman Allyn Art Museum,
New London, Connecticut

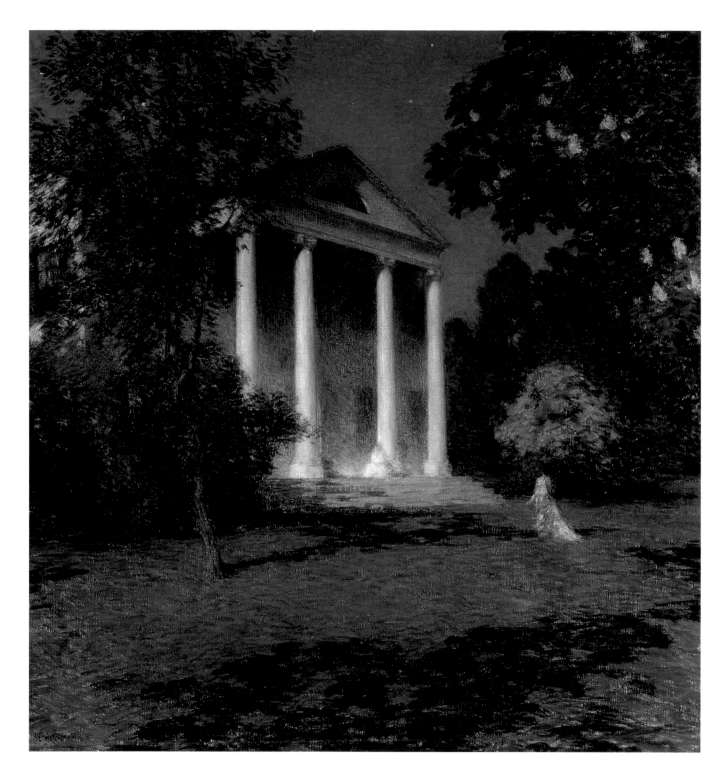

40.
Willard Metcalf
May Night, 1906
Oil on canvas
39 1/2 x 36 3/8 inches
In the Collection of the
Corcoran Gallery of Art,
Museum Purchase, Gallery Fund

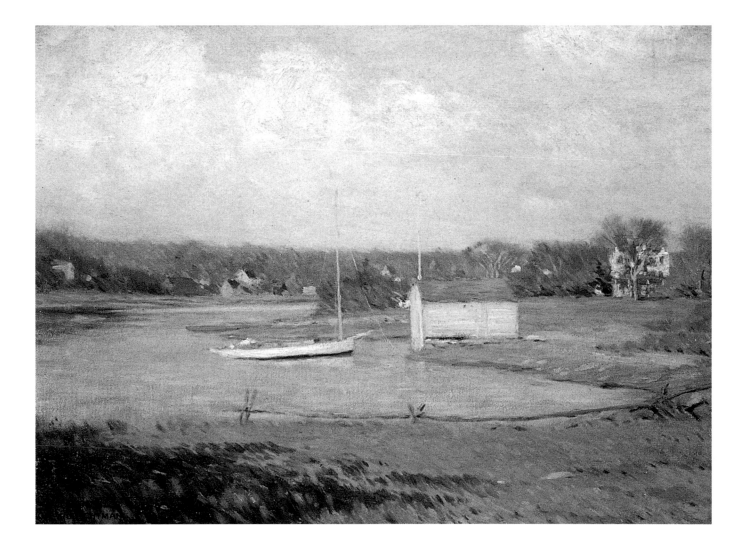

41.
Leonard Ochtman (1854–1934)
On the Mianus River, 1896
Oil on canvas
16 x 22 inches
The Bruce Museum,
Greenwich, Connecticut

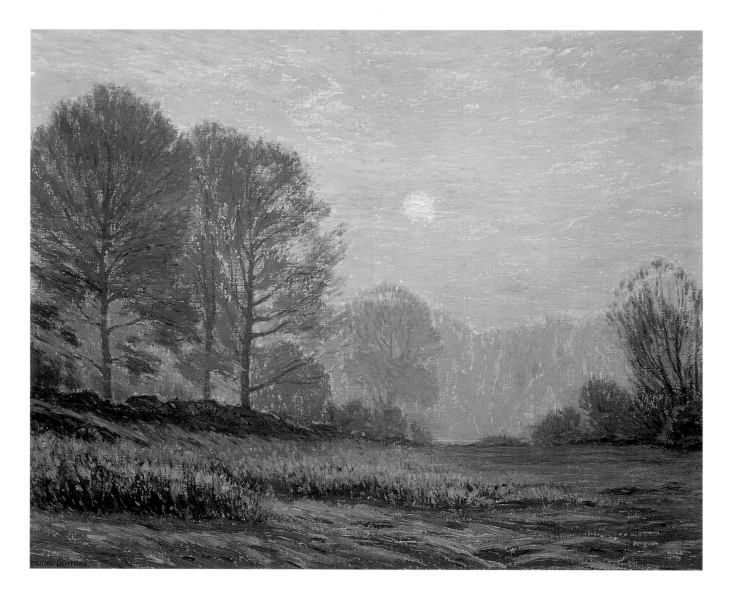

42.
Leonard Ochtman
October Morning, 1919
Oil on canvas
24 x 30 inches
The Bruce Museum,
Greenwich, Connecticut

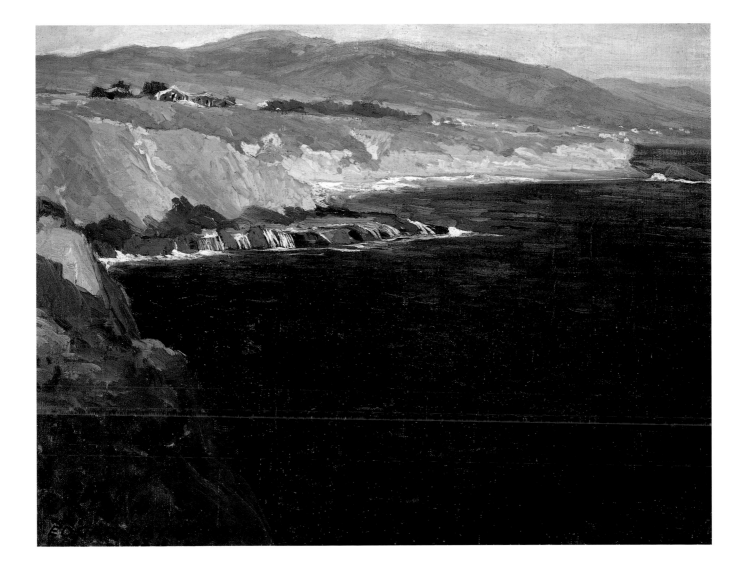

43.
Edgar A. Payne (1883–1947)
Old Laguna, 1911
Oil on canvas
18 x 23 inches
The Irvine Museum,
Irvine, California

44.
Granville Redmond (1871–1935)
Laguna Morning, 1911
Oil on canvas
18 x 30 inches
Jeffrey and Nancy Gundlach,
Los Angeles

45.
Granville Redmond
Poppies and Lupines, 1912
Oil on canvas
20 1/4 x 30 1/4 inches
Private Collection

46.
Granville Redmond
Silver and Gold, c. 1918
Oil on canvas
30 x 40 inches
Laguna Art Museum/Orange County Museum
of Art Collection Trust, California,
Gift of Mr. and Mrs. J. G. Redmond

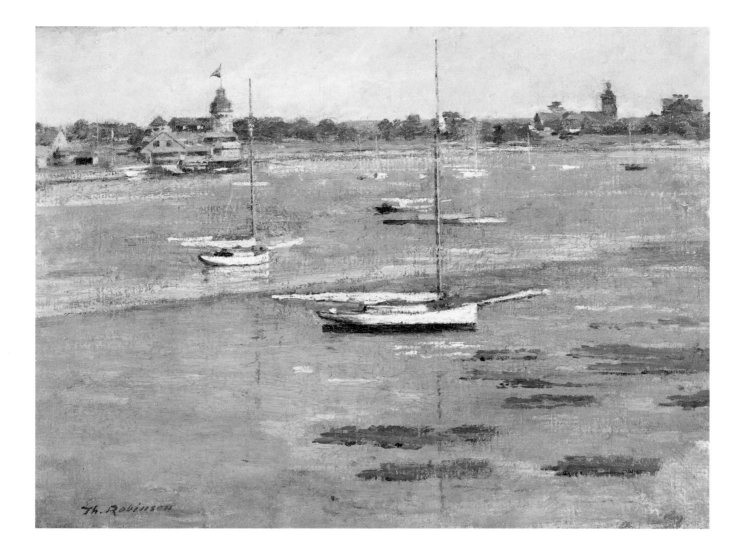

47.
Theodore Robinson (1852–1896)
Low Tide, 1894
Oil on canvas
16 x 22 1/4 inches
Manoogian Collection

48.
Guy Rose (1865–1925)
Laguna Shores, c. 1916
Oil on canvas
21 1/2 x 24 1/2 inches
Mr. and Mrs. Thomas B. Stiles II

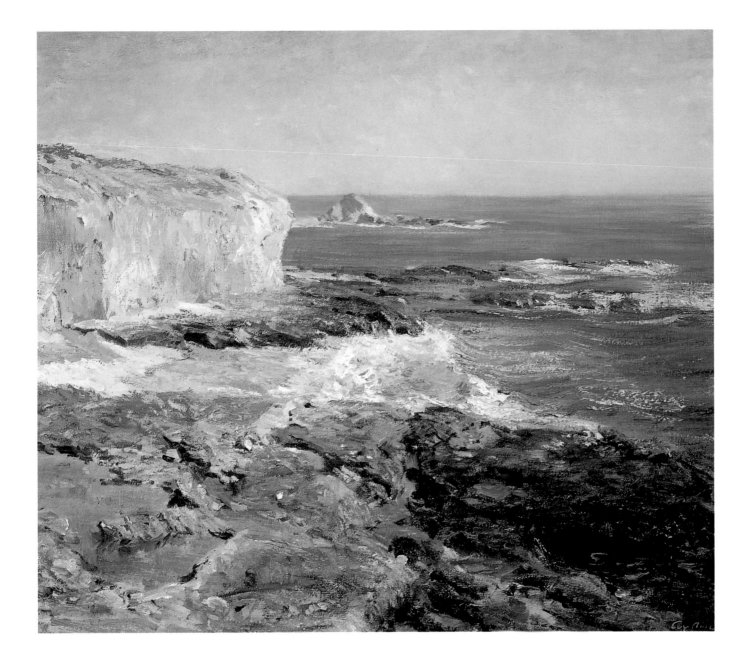

49.
Guy Rose
Laguna Rocks, Low Tide, c. 1916–17
Oil on canvas
21 x 24 inches
The Joan Irvine Smith Collection

50.
Donna Schuster (1883–1953)
Lily Pond, Capistrano Mission, c. 1928
Oil on canvas
24 x 30 inches
Ranney and Priscilla Draper

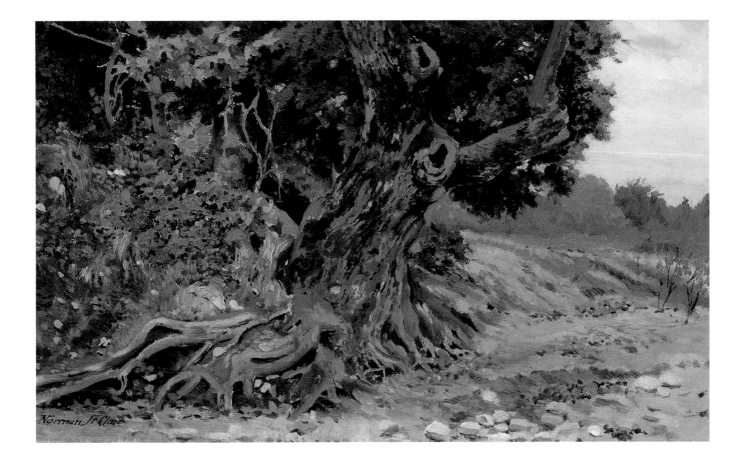

51.
Norman St. Clair (1865–1915)
Old Oak Tree, Laguna Canyon, c. 1900
Oil on canvas on board
12 x 20 inches
DeRu's Fine Arts,
Laguna Beach, California

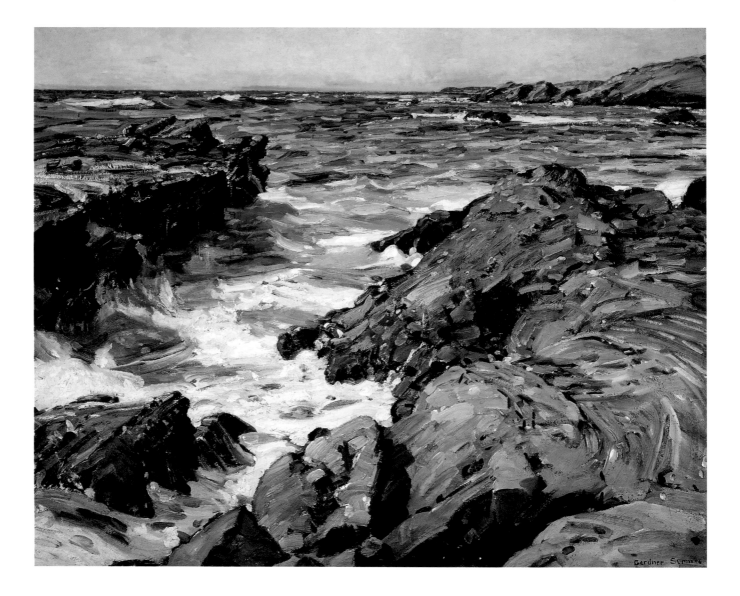

52.
George Gardner Symons (1861–1930)
Under a Blue Sky, c. 1915–20
Oil on canvas
40 x 50 inches
The Redfern Gallery,
Laguna Beach, California

53.
Mary Titcomb (1856–1927)
Church at Old Lyme, n.d.
Oil on canvas
21 1/2 x 17 inches
Joseph Ambrose, Jr.

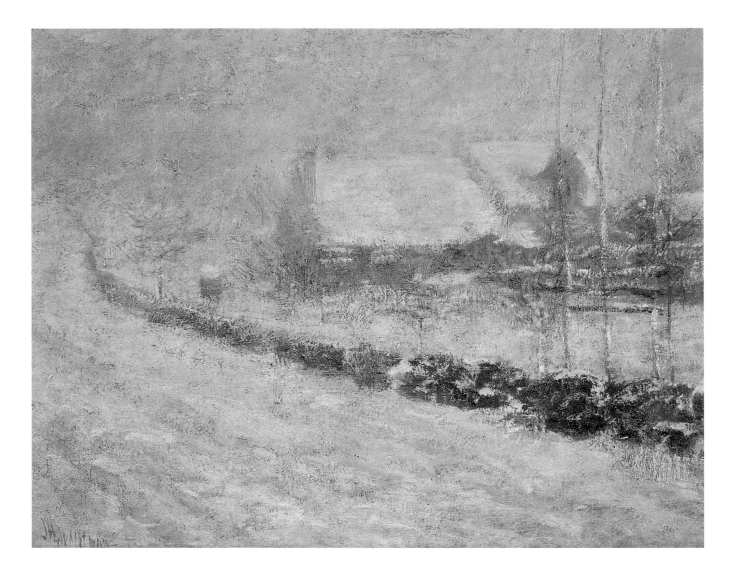

54.
John Henry Twachtman (1853–1902)
Snowbound, c. 1893
Oil on canvas
22 x 30 1/8 inches
Scripps College, Claremont, California,
Gift of General and Mrs. Edward Clinton Young, 1946

55.
John Henry Twachtman
Pond in Spring, c. early 1890s
Oil on board
15 1/4 x 18 1/2 inches
Spanierman Gallery, LLC, New York

56.
Robert Vonnoh (1858–1933)
Amber and Grey, Lyme, Connecticut, c. 1920
Oil on canvas
25 x 30 inches
Private Collection

57.
Clark Voorhees (1871–1933)
My Garden, c. 1913
Oil on canvas
28 x 36 inches
Michael W. Voorhees

58.
J. Alden Weir (1852–1919)
Path in the Woods, n.d.
Oil on canvas
24 x 29 inches
Lyman Allyn Art Museum,
New London, Connecticut

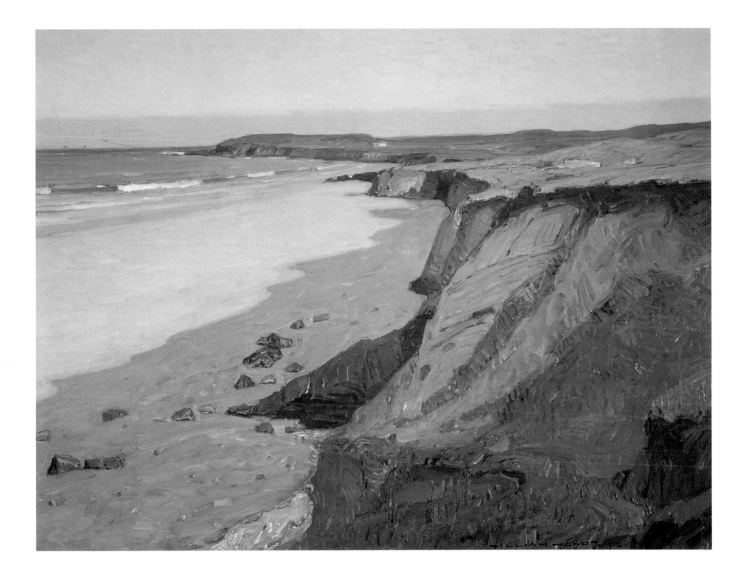

59.
William Wendt (1865–1946)
Crystal Cove, 1912
Oil on canvas
28 x 36 inches
Joan Irvine Smith Fine Arts, Inc.,
Laguna Beach, California

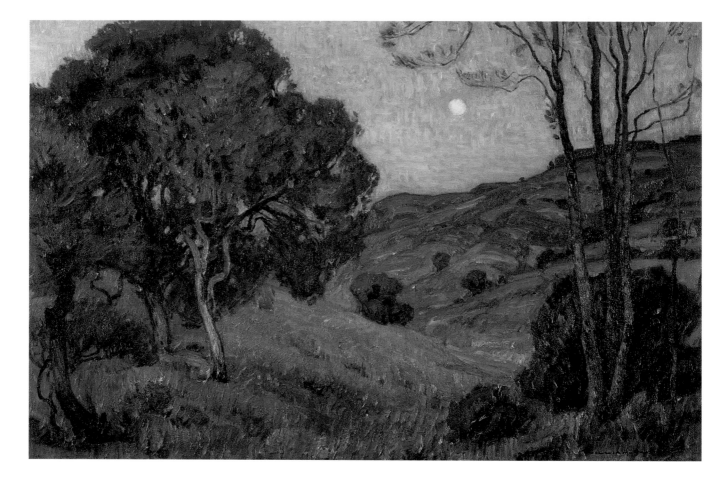

60.
William Wendt
Twilight (*Moulton Ranch Near Laguna*), c. 1915
Oil on canvas
24 x 36 inches
Mr. and Mrs. Thomas B. Stiles II

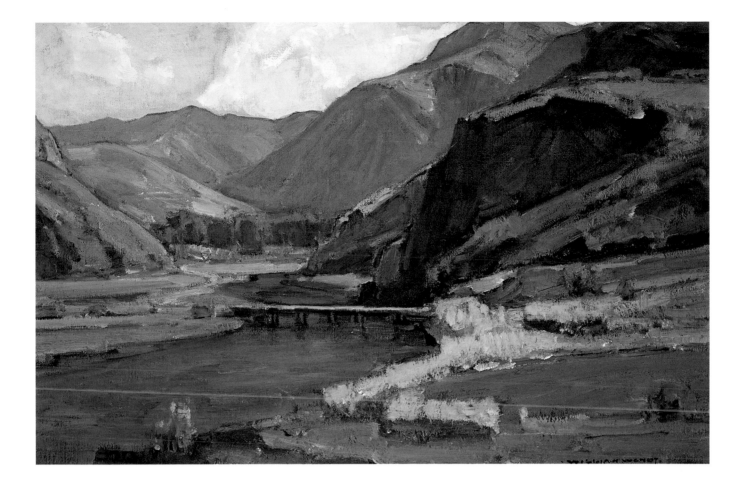

61.
William Wendt
Old Coast Highway Bridge, 1917
Oil on canvas
16 x 24 inches
Ranney and Priscilla Draper

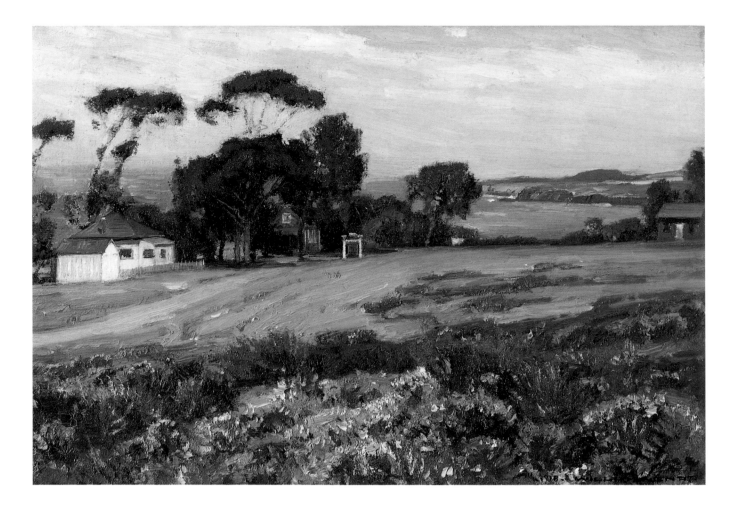

62.
William Wendt
Old Pacific Coast Highway, 1918
Oil on canvas
12 x 16 inches
Mr. and Mrs. Thomas B. Stiles II

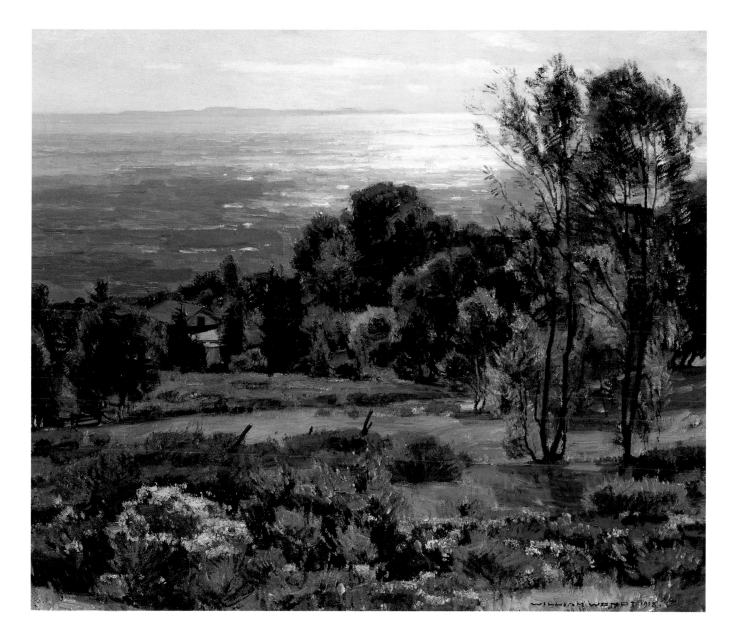

63.
William Wendt
The Overton Cottage and Old Highway, 1918
Oil on canvas
25 x 30 inches
William A. Karges

64.
William Wendt
Sycamores in Laguna Canyon, c. 1920–25
Oil on canvas
30 x 40 inches
Ranney and Priscilla Draper

65.
William Wendt
Seaside Cottages, c. 1930
Oil on canvas
30 x 36 inches
Private Collection

66.
William Wendt
Sermons in Stone, 1934
Oil on canvas
28 x 36 inches
Joan Irvine Smith Fine Arts, Inc.,
Laguna Beach, California

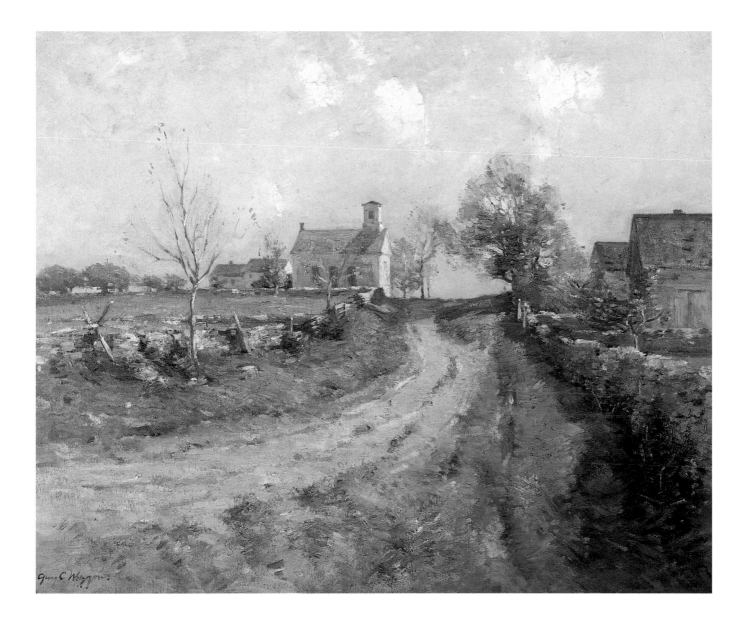

67.
Guy Wiggins (1883–1962)
Church on the Hill, c. 1910–12
Oil on canvas
27 x 32 inches
Lyman Allyn Art Museum,
New London, Connecticut

68.
Karl Yens (1868–1945)
Studio Interior, Laguna Beach, 1912
Oil on board
14 x 10 inches
Private Collection
Photograph courtesy of DeRu's Fine Arts,
Laguna Beach, California

Catalogue of the Exhibition

All works of art in the exhibtion have been reproduced in this catalogue alphabetically from front to back.

1.
George Brandriff (1890–1936)
Diver's Cove, Laguna Beach, c. 1930
Oil on canvas
24 x 28 inches
Marcel Vinh and Daniel Hansman

2.
George Brandriff
Studio, Laguna Beach, c. 1930
Oil on canvas
24 x 28 inches
Private Collection

3.
Benjamin Chambers Brown (1865–1942)
The Jeweled Shore, c. 1923
Oil on canvas
34 x 36 inches
Private Collection

4.
George Brainerd Burr (1876–1939)
Old Lyme Garden, n.d.
Oil on panel
12 x 9 inches
Florence Griswold Museum,
Old Lyme, Connecticut,
Gift of Mrs. Patricia Burr Bott

5.
William Chadwick (1879–1962)
On the Porch, c. 1908–1910
Oil on canvas
24 x 30 inches
Florence Griswold Museum,
Old Lyme, Connecticut,
Gift of Elizabeth Chadwick O'Connell

6.
William Merritt Chase (1849–1916)
The Chase Homestead, Shinnecock, c. 1893
Oil on panel
14 1/2 x 16 1/8 inches
San Diego Museum of Art,
Gift of Mrs. Walter Harrison Fisher

7.
Frank W. Cuprien (1871–1948)
Poème du Soir, 1925
Oil on canvas
32 x 35 inches
Laguna Art Museum/Orange County
Museum of Art Collection Trust, California,
Gift of the Estate of Frank W. Cuprien

8.
Frank W. Cuprien
Evening's Iridescence, c. 1925–30
Oil on canvas
32 x 48 inches
Joan Irvine Smith Fine Arts, Inc.,
Laguna Beach, California

9.
Frank W. Cuprien
The Old Bait House, c. 1925–30
Oil on canvas
24 x 28 inches
Private Collection

10.
William Swift Daniell (1865–1933)
My Studio, Laguna Beach, c. 1920
Oil on canvas
16 x 20 inches
Laguna Art Museum/Orange County
Museum of Art Collection Trust, California

11.
Charles Davis (1856–1933)
Sky, c. 1922
Oil on canvas
36 x 30 inches
Lyman Allyn Art Museum,
New London, Connecticut

12.
Frank Vincent DuMond (1865–1951)
Grassy Hill, 1933
Oil on canvas
24 1/4 x 30 1/2 inches
Florence Griswold Museum,
Old Lyme, Connecticut,
Gift of Mrs. Walter Perry

13.
Charles Ebert (1873–1959)
Water's Edge, n.d.
Oil on canvas
19 7/8 x 27 inches
Florence Griswold Museum,
Old Lyme, Connecticut,
Gift of Miss Elisabeth Ebert

14.
Charles Ebert
Lieutenant River, Old Lyme, Connecticut, c. 1920
Oil on canvas
30 x 41 1/2 inches
Spanierman Gallery, LLC, New York

15.
Edmund W. Greacen (1876–1949)
Shipyard, Old Lyme, Connecticut, c. 1910
Oil on canvas
16 x 20 inches
Spanierman Gallery, LLC, New York

16.
Edmund W. Greacen
The Old Garden, c. 1912
Oil on canvas
30 1/2 x 30 1/2 inches
Florence Griswold Museum,
Old Lyme, Connecticut,
Gift of Mrs. Edmund Greacen, Jr.

17.
William Griffith (1866–1940)
In Laguna Canyon, 1928
Oil on canvas
30 x 40 inches
The Irvine Museum,
Irvine, California

18.
Frederick Childe Hassam (1859–1935)
The Smelt Fishers, Cos Cob, 1896
Oil on canvas
22 1/4 x 17 1/2 inches
The Fine Arts Museums of San Francisco,
Gift of Rawson Kelham to the Fine Arts
Museums of San Francisco, 1989

19.
Frederick Childe Hassam
The Mill Pond, Cos Cob, Connecticut, 1902
Oil on canvas
26 1/4 x 18 1/4 inches
The Bruce Museum,
Greenwich, Connecticut

20.
Frederick Childe Hassam
Stone Bridge, Old Lyme, Connecticut, 1905
Oil on canvas
18 x 22 inches
San Diego Museum of Art,
Gift of Gerald and
Inez Grant Parker Foundation

21.
Frederick Childe Hassam
Clarissa, 1912
Oil on canvas
24 x 22 inches
The Historical Society of the Town
of Greenwich, Connecticut

22.
Anna Hills (1882–1930)
High Tide, Laguna Beach, 1914
Oil on canvas
20 x 30 inches
Private Collection
Photograph courtesy of DeRu's Fine Arts,
Laguna Beach, California

23.
Clarence Hinkle (1880–1960)
Thoughts, c. 1915
Oil on canvas
36 x 30 inches
The Redfern Gallery,
Laguna Beach, California

24.
Clarence Hinkle
Beach Scene, c. 1925–30
Oil on canvas
18 1/4 x 22 1/4 inches
George Stern Fine Arts,
West Hollywood, California

25.
Clarence Hinkle
Overlooking Laguna, c. 1925–30
Oil on canvas
30 x 36 inches
Mr. and Mrs. Thomas B. Stiles II

26.
Wilson Irvine (1869–1936)
Lois, c. 1914
Oil on canvas
27 x 24 inches
Spanierman Gallery, LLC, New York

27.
William Lees Judson (1842–1928)
Bluebird Canyon, Laguna Beach, c. 1912
Watercolor
17 x 22 inches
Joan Irvine Smith Fine Arts, Inc.,
Laguna Beach, California

28.
William Lees Judson
Early Spring, Laguna Beach, c. 1912
Watercolor
17 x 22 inches
Joan Irvine Smith Fine Arts, Inc.,
Laguna Beach, California

29.
William Lees Judson
Sleepy Hollow, Laguna Beach, c. 1912
Watercolor
17 x 22 inches
Joan Irvine Smith Fine Arts, Inc.,
Laguna Beach, California

30.
William Lees Judson
Temple Hill, Laguna Beach, c. 1912
Watercolor
17 x 22 inches
Joan Irvine Smith Fine Arts, Inc.,
Laguna Beach, California

31.
Joseph Kleitsch (1882–1931)
The Old Post Office, c. 1922–23
Oil on canvas
40 x 34 inches
Laguna Art Museum/Orange County
Museum of Art Collection Trust, California,
Gift of the Estate of Joseph Kleitsch
in Memory of His Wife Edna

32.
Joseph Kleitsch
Old Laguna, c. 1922–25
Oil on canvas
18 x 21 inches
The Redfern Gallery,
Laguna Beach, California

33.
Joseph Kleitsch
The Green House, 1930
Oil on canvas
36 x 40 inches
Joseph Ambrose, Jr.

34.
Joseph Kleitsch
Curiosity, c. 1923–24
Oil on canvas
25 x 30 inches
Mr. and Mrs. Thomas B. Stiles II

35.
Joseph Kleitsch
Hotel Laguna, 1924
Oil on canvas
16 x 20 inches
Michael D. Feddersen

36.
Joseph Kleitsch
Laguna Beach, 1925
Oil on canvas
16 x 20 inches
Michael D. Feddersen

37.
Elmer MacRae (1875–1953)
Railroad Bridge, Winter, 1907
Oil on canvas
22 x 27 inches
The Bruce Museum,
Greenwich, Connecticut

38.
Elmer MacRae
Japanese Iris, 1914
Oil on canvas
24 x 20 inches
Historical Society of the Town of
Greenwich, Connecticut

39.
Willard Metcalf (1858–1925)
The Green Meadow, 1919
Oil on canvas
26 x 29 inches
Lyman Allyn Art Museum,
New London, Connecticut

40.
Willard Metcalf
May Night, 1906
Oil on canvas
39 1/2 x 36 3/8 inches
In the Collection of the
Corcoran Gallery of Art,
Museum Purchase, Gallery Fund

41.
Leonard Ochtman (1854–1934)
On the Mianus River, 1896
Oil on canvas
16 x 22 inches
The Bruce Museum,
Greenwich, Connecticut

42.
Leonard Ochtman
October Morning, 1919
Oil on canvas
24 x 30 inches
The Bruce Museum,
Greenwich, Connecticut

43.
Edgar A. Payne (1883–1947)
Old Laguna, 1911
Oil on canvas
18 x 23 inches
The Irvine Museum,
Irvine, California

44.
Granville Redmond (1871–1935)
Laguna Morning, 1911
Oil on canvas
18 x 30 inches
Jeffrey and Nancy Gundlach,
Los Angeles

45.
Granville Redmond
Poppies and Lupines, 1912
Oil on canvas
20 1/4 x 30 1/4 inches
Private Collection

46.
Granville Redmond
Silver and Gold, c. 1918
Oil on canvas
30 x 40 inches
Laguna Art Museum/Orange County
Museum of Art Collection Trust, California,
Gift of Mr. and Mrs. J.G. Redmond

47.
Theodore Robinson (1852–1896)
Low Tide, 1894
Oil on canvas
16 x 22 1/4 inches
Manoogian Collection

48.
Guy Rose (1865–1925)
Laguna Shores, c. 1916
Oil on canvas
21 1/2 x 24 1/2 inches
Mr. and Mrs. Thomas B. Stiles II

49.
Guy Rose
Laguna Rocks, Low Tide, c. 1916–17
Oil on canvas
21 x 24 inches
The Joan Irvine Smith Collection

50.
Donna Schuster (1883–1953)
Lily Pond, Capistrano Mission, c. 1928
Oil on canvas
24 x 30 inches
Ranney and Priscilla Draper

51.
Norman St. Clair (1865–1915)
Old Oak Tree, Laguna Canyon, c. 1900
Oil on canvas on board
12 x 20 inches
DeRu's Fine Arts,
Laguna Beach, California

52.
George Gardner Symons (1861–1930)
Under a Blue Sky, c. 1915–20
Oil on canvas
40 x 50 inches
The Redfern Gallery,
Laguna Beach, California

53.
Mary Titcomb (1856–1927)
Church at Old Lyme, n.d.
Oil on canvas
21 1/2 x 17 inches
Joseph Ambrose, Jr.

54.
John Henry Twachtman (1853–1902)
Snowbound, c. 1893
Oil on canvas
22 x 30 1/8 inches
Scripps College, Claremont, California,
Gift of General and Mrs. Edward
Clinton Young, 1946

55.
John Henry Twachtman
Pond in Spring, c. early 1890s
Oil on board
15 1/4 x 18 1/2 inches
Spanierman Gallery, LLC, New York

56.
Robert Vonnoh (1858–1933)
Amber and Grey, Lyme, Connecticut, c. 1920
Oil on canvas
25 x 30 inches
Private Collection

57.
Clark Voorhees (1871–1933)
My Garden, c. 1913
Oil on canvas
28 x 36 inches
Michael W. Voorhees

58.
J. Alden Weir (1852–1919)
Path in the Woods, n.d.
Oil on canvas
24 x 29 inches
Lyman Allyn Art Museum,
New London, Connecticut

59.
William Wendt (1865–1946)
Crystal Cove, 1912
Oil on canvas
28 x 36 inches
Joan Irvine Smith Fine Arts, Inc.,
Laguna Beach, California

60.
William Wendt
Twilight (Moulton Ranch Near Laguna), c. 1915
Oil on canvas
24 x 36 inches
Mr. and Mrs. Thomas B. Stiles II

61.
William Wendt
Old Coast Highway Bridge, 1917
Oil on canvas
16 x 24 inches
Ranney and Priscilla Draper

62.
William Wendt
Old Pacific Coast Highway, 1918
Oil on canvas
12 x 16 inches
Mr. and Mrs. Thomas B. Stiles II

63.
William Wendt
The Overton Cottage and Old Highway, 1918
Oil on canvas
25 x 30 inches
William A. Karges

64.
William Wendt
Sycamores in Laguna Canyon, c. 1920–25
Oil on canvas
30 x 40 inches
Ranney and Priscilla Draper

65.
William Wendt
Seaside Cottages, c. 1930
Oil on canvas
30 x 36 inches
Private Collection

66.
William Wendt
Sermons in Stone, 1934
Oil on canvas
28 x 36 inches
Joan Irvine Smith Fine Arts, Inc.,
Laguna Beach, California

67.
Guy Wiggins (1883–1962)
Church on the Hill, c. 1910–12
Oil on canvas
27 x 32 inches
Lyman Allyn Art Museum,
New London, Connecticut

68.
Karl Yens (1868–1945)
Studio Interior, Laguna Beach, 1912
Oil on board
14 x 10 inches
Private Collection
Photograph courtesy of
DeRu's Fine Arts,
Laguna Beach, California

Laguna Art Museum